A STICKY NOTE
GUIDE TO LIFE

HarperCollins**Publishers**
1 London Bridge Street
London SE1 9GF

www.harpercollins.co.uk

First published by HarperCollins**Publishers** 2016
1 3 5 7 9 10 8 6 4 2

A catalogue record of this book is
available from the British Library

ISBN 978-0-00-818762-0

Printed and bound in China

MIX
Paper from
responsible sources
FSC C007454

FSC™ is a non-profit international organisation established to promote
the responsible management of the world's forests. Products carrying the FSC label are
independently certified to assure consumers that they come from forests that are managed
to meet the social, economic and ecological needs of present and future generations,
and other controlled sources.

Find out more about HarperCollins and the environment at
www.harpercollins.co.uk/green

A STICKY NOTE GUIDE TO LIFE

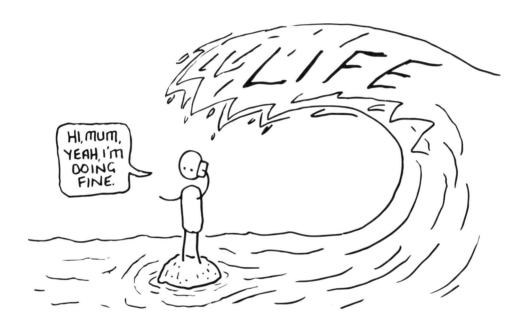

CHAZ HUTTON

HarperCollins*Publishers*

Dedicated to Jeff Goldblum
(who still hasn't followed me back)

CONTENTS

INTRODUCTION

I should say something.

Maybe I'll start with an apology. First of all, I'm sorry to be so misleading. This book is called *A Sticky Note Guide to Life*, however I sincerely hope you haven't picked this up hoping to be guided through life in any way. There is actually very little good advice to be found anywhere within these pages. There is, however, a hell of a lot of questionable advice and nonsense wrapped up in general idiocy, which, let's be honest, is far more entertaining than any 'good advice' (which you wouldn't have listened to anyway).

As you might be aware, this book started as an Instagram account and, like some delicate animal raised in captivity, at a certain point it got big and bad enough to warrant being released into the wilds of bookstores and Amazon pages. I sincerely hope you've discovered it gorging on the littered remains of a bigoted politician's memoir or alternatively the shredded carcass of a vlogger's book (us Instagrammers and YouTubers are mortal enemies, in case you're new to this). Regardless, I'm glad you've got hold of this wily beast and are now doggedly dragging it by the collar, trying to get it home. Or maybe you're not. Maybe you're just standing there, reading it in a bookstore while you wait for your partner or friend to finish up whatever it is they dragged you down here for. In that case, I think you've just about maxed out on the time you can read a book in a store without buying it, so pick a lane, put this back and have a laugh at that stupid politician's book. Or maybe marvel at how a video blog can make the transition into book format. Or go slam this down on the counter and reveal yourself as someone who thoroughly enjoys low-brow nonsense purveyed through the medium of crudely drawn comics on sticky notes.

What else do I need to tell you before you delve into this thing? I feel like I need to prepare you for what follows, but in reality, it's just a bunch of drawings on small pieces of paper.

I'll leave you with this thought. The intention from the very beginning – before the Instagramming started – when drawing stuff like this was still a procrastination tool for me as I stared down the barrel of a 9–5 office job, was to waste as much time as possible as 5pm glacially approached. So, I hope that the following 200-something pages provide ample time-wasting material for you. I hope you fail to do whole swathes of important stuff you had lined up today, and I hope this will inspire you to waste even more time thereafter.

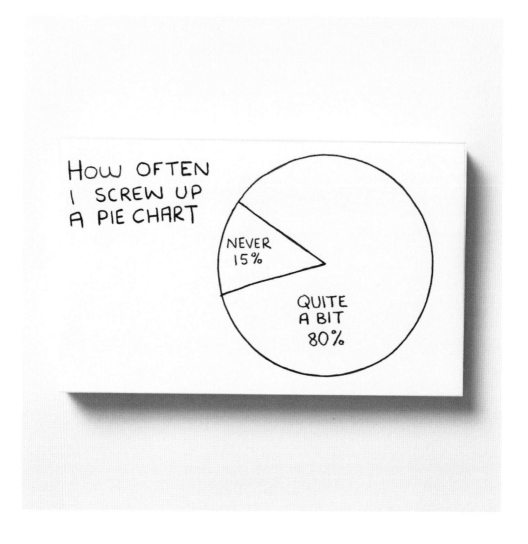

Here's some graphs to get you started. Yes, this might look like a funny, tongue-in-cheek pie chart, but it is deadly serious. Do you realise how many sticky notes it takes me to get a final sticky-note drawing? I'm not going to tell you, but suffice it to say that if I did I'd be boycotted by every self-respecting environmental group for bearing sole responsibility for quite a bit of Amazonian deforestation.

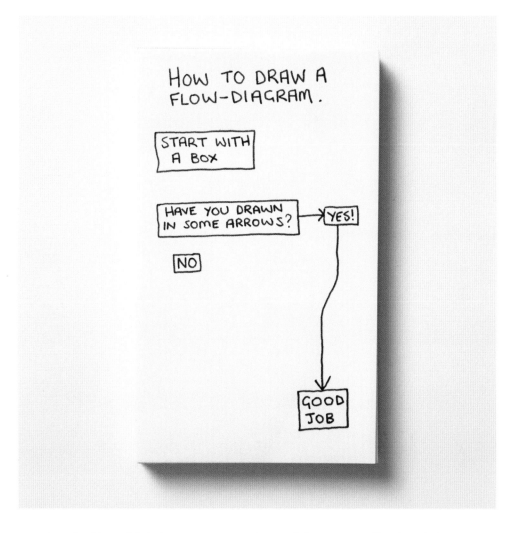

I thought I'd put this in just so you can understand the amount of hard work that goes into drawing this kind of stuff. And yes, your suspicions are correct. You could totally have written this book.

That said, try quitting your successful architecture job by telling your employer that you've decided to 'draw stuff on sticky notes full time', while you hope they haven't noticed that you've got the entire office's supply of sticky notes taped to your body.

Anyway, let's do this.

WORK

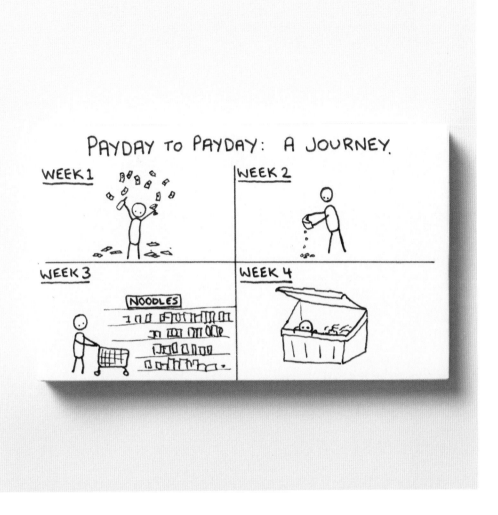

'I deserve to celebrate and spend all my money as a reward for surviving the previous two weeks, and no, I don't care that doing that perpetuates a vicious cycle of recurring debt because I've already had three Martinis and you're not my real dad.'

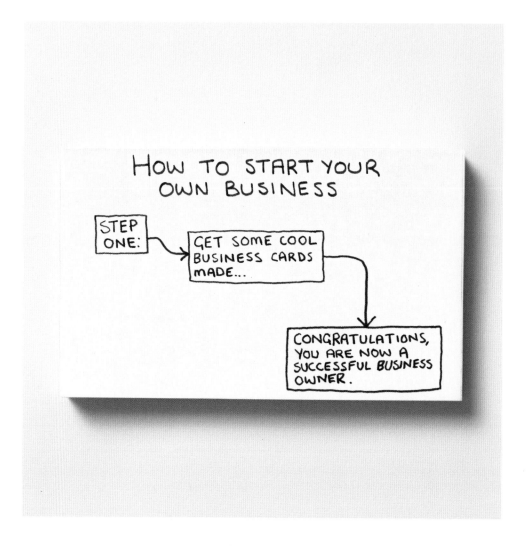

Give these cards to as many of your friends and family as you can. Under no circumstances should you do anything that might resemble work, because, you know, *it's still early days*.

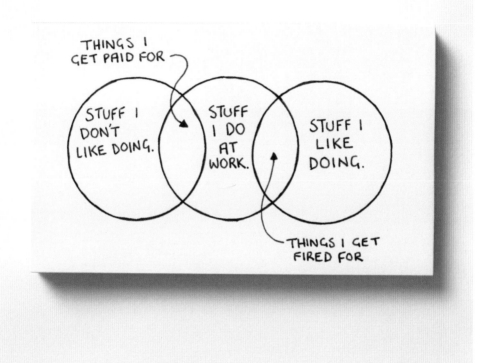

People who unthinkingly regurgitate pseudo-philosophical platitudes will tell you that you should *find something you love, and then make it your job*. However, I am yet to find anyone willing to pay me to stand around completely naked and half drunk while microwaving different fruit just to see what happens to it after certain amounts of time.

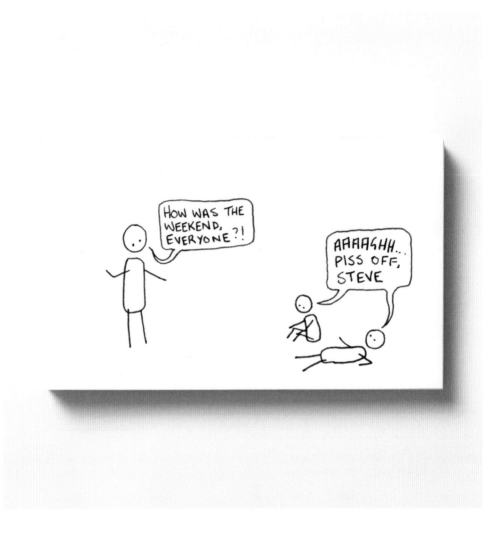

Before you engage on a Monday, consider the following. Are you sure you're genuinely interested in what your work colleague did on the weekend, or are you simply using that thoughtless Monday greeting because you don't have much of a connection with them and you're just desperately trying to construct some kind of engineered friendship for the sake of being polite while you momentarily share the same space in the office kitchen?

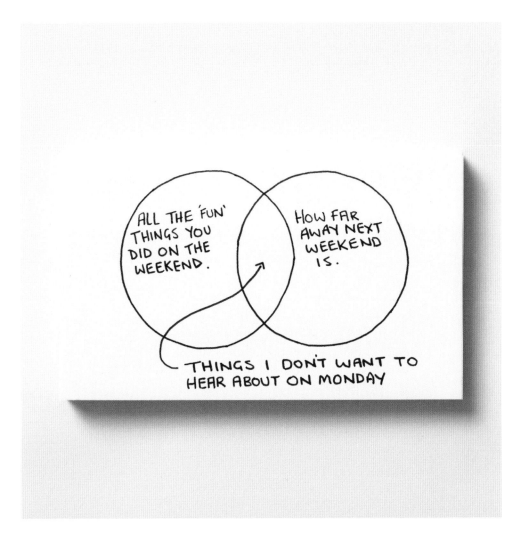

The same applies to holidays as well. I know you had a great time and that you experienced a whole bunch of amazing stuff, but your amazing retelling of it isn't even close to experiencing it in person. If anything, you should probably have spent the weekend doing a storytelling workshop run by an esteemed raconteur.

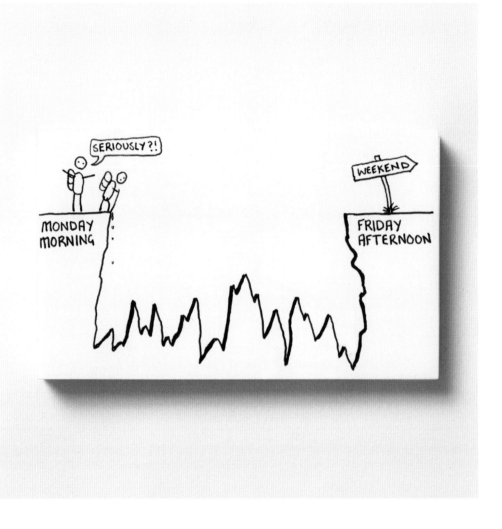

As you stand there, looking out over the treacherous week ahead of you, know that down every crevasse is a meeting that could have been an email, behind every insurmountable boulder is a work colleague asking about your weekend and at the top of every tricky climb is a boss still unwilling to give you a pay rise. However, once you haul yourself up by the fingernails at the other end and kick the dusty remains of IT issues, midweek hangovers and bad work coffee from your boots, you'll have arrived on a small ledge made up of two glorious days, where you can stand up, take in the view, check out the next canyon in the distance and rightfully complain that the ledge really isn't big enough.

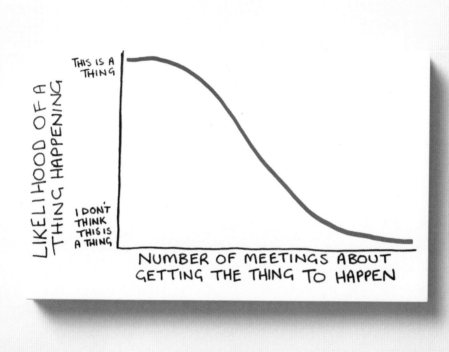

'Okay, so let's recap. We've failed to agree on anything or resolve any of the outstanding issues, although we have agreed when the next meeting should be held, and as far as I can tell everyone has quite enjoyed not having to do any work for the last half-hour, so good job, everyone.'

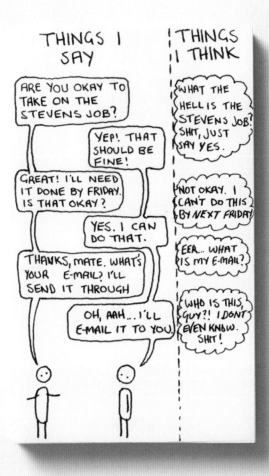

This is more or less a visualisation of the first five or six years of what I humorously refer to as my 'professional career' (which was barely long enough to count as a career and could rarely be deemed as particularly professional). I'd like to take this opportunity to explain to all those exasperated work colleagues who had to try to decipher just exactly what was going on behind my mostly vacant facial expression at the time, the answer to which would be, 'Not much.'

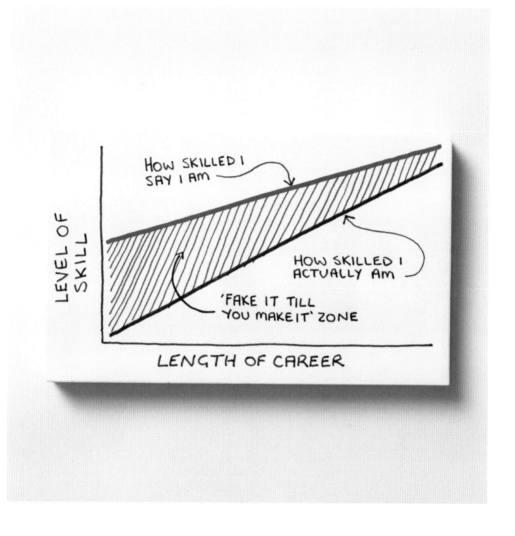

People always offer up that advice when you're starting out – the old *Fake it till you make it* – but what the advice should really be is: *Understand that everyone else is faking it till they make it, no matter how long they've been doing it.*

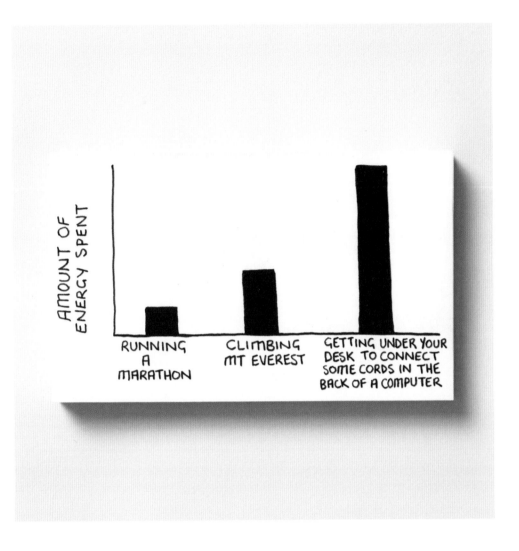

I hate going to the gym. However, I think there's a market for a gym that would be just a whole lot of office desks in a room and you had to crawl under one and connect cords until the screen above it finally worked, at which point you get given a pat on the back and are allowed to go home, happy in the knowledge that you did a great workout while also getting a computer to work. Unlike a real office, where you get labelled as *the guy who can fix computers* and become some kind of enslaved desk-dwelling IT troglodyte (albeit one with terrific core strength).

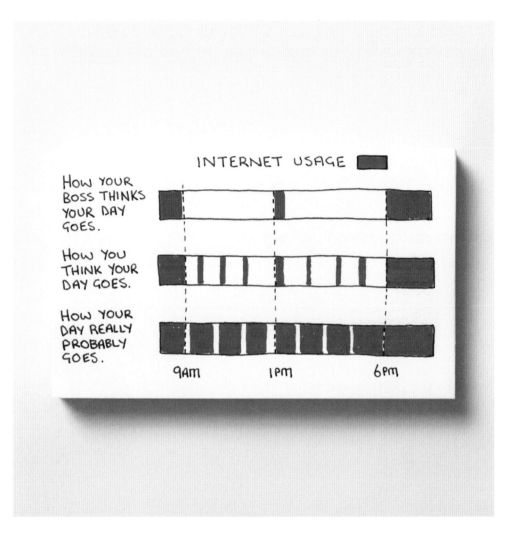

It's now nearly impossible to work out if the internet has increased mankind's rate of innovation or actually slowed it down a bit with the collective number of hours we've lost to cat videos.

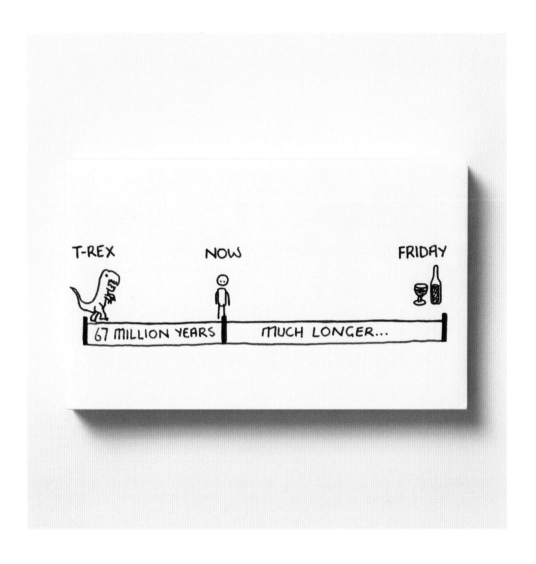

Against all rational explanation, the distance between now and Friday actually increases the closer you get to Friday, which is about as close as you're going to get to experiencing quantum mechanics.

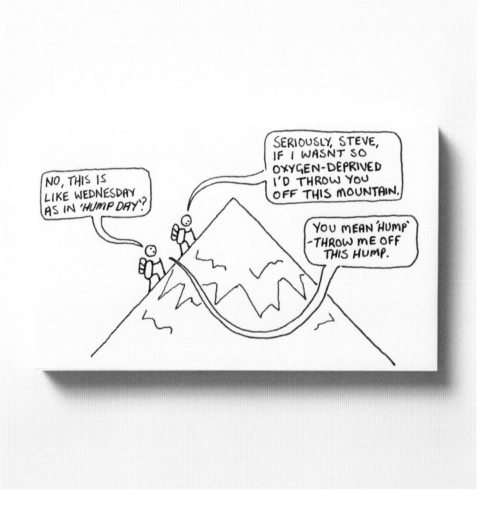

Stop it. Just. Stop it. Nobody cares about your cute little name for Wednesday. Most of the people in this office that you assume are your friends are already considering not telling you about their Friday after-work drinks plans, and you excitedly proclaiming that Wednesday represents the peak of a metaphorical week-long mountain as you bound into the office is probably going to clinch it for them.

I know, the truth hurts.

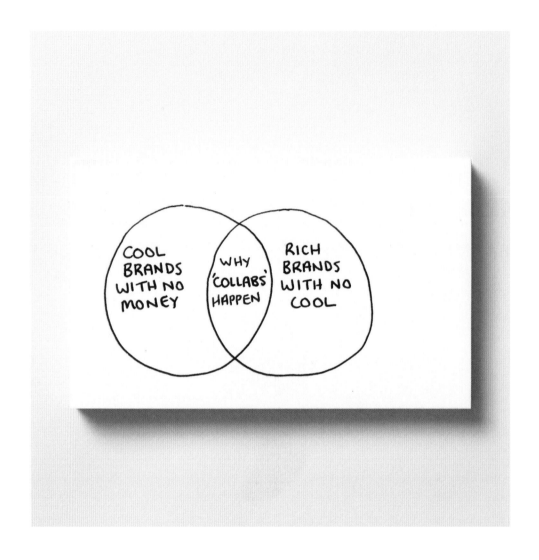

If you're the one in the collab fronting up most of the money, I've got bad news for you.

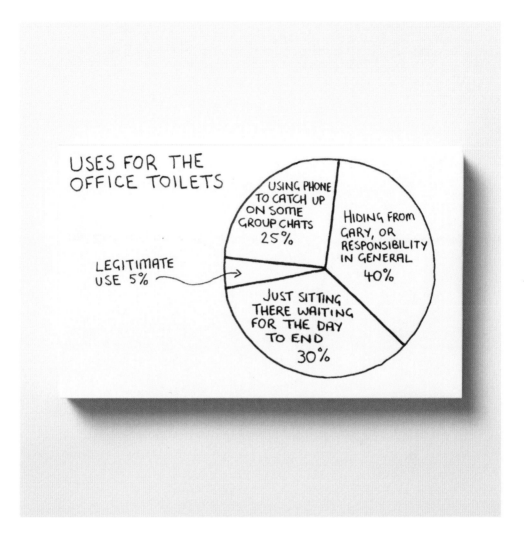

'Where have you been for the last two hours?'

'Um ... in a meeting ... with, aaah ... myself ... which was a private meeting that I also can't talk about. Anyway, I'm going home now, bye!'

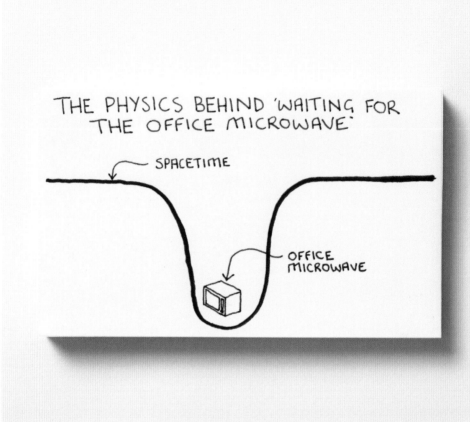

Newton, Einstein, Hawking. These are just a few people who have no idea what they're talking about when it comes to astrophysics and spacetime. What none of them identified was that the Earth's gravitational pull is actually created by a concentration of work microwaves. Put enough work microwaves in a room and you'll slow time to a standstill while you stare into the abyss that is Linda's leftover Indian takeaway, slowly reheating for eternity.

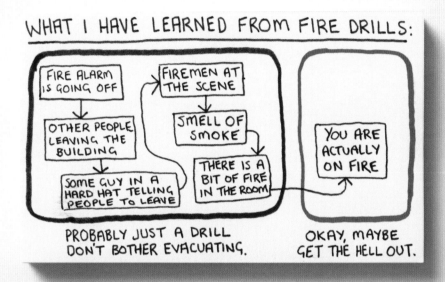

If we're going to have a fire drill, let's do it properly and set the building on fire. Make that thing realistic.

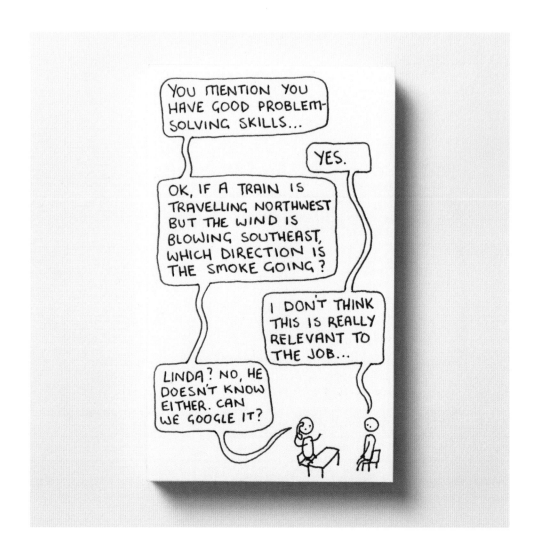

What about the whole 'chicken and egg' thing? Any thoughts there?

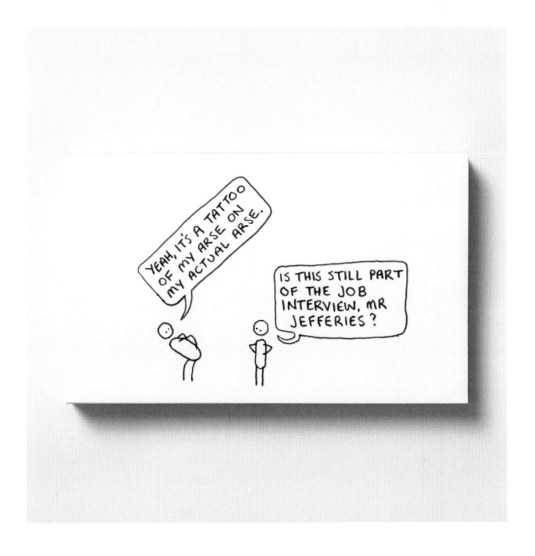

'Job interview?! I don't even work here.'

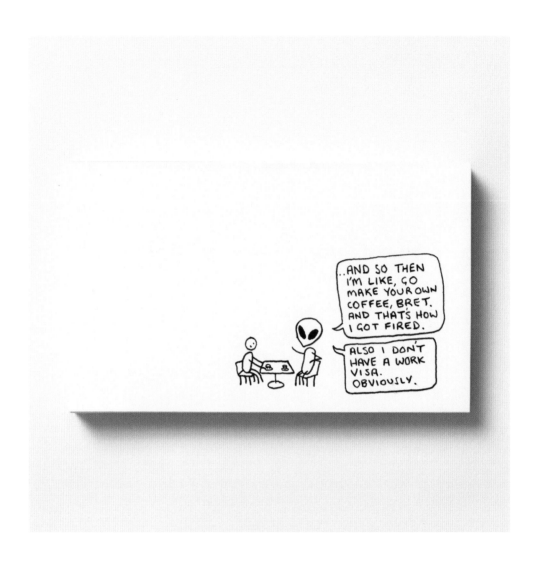

'Also, the rent in this town is astronomically high – and I should know.'

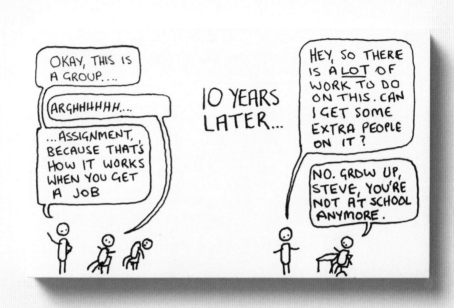

I want to see universities creating real-life work environments, where basically one person is charged with getting the project done, and then two or three people need to work under them, but these two or three people will obviously be either working on a different project at an entirely different university or they'll just call in sick and be entirely unavailable. Everyone will still get a pass for the project.

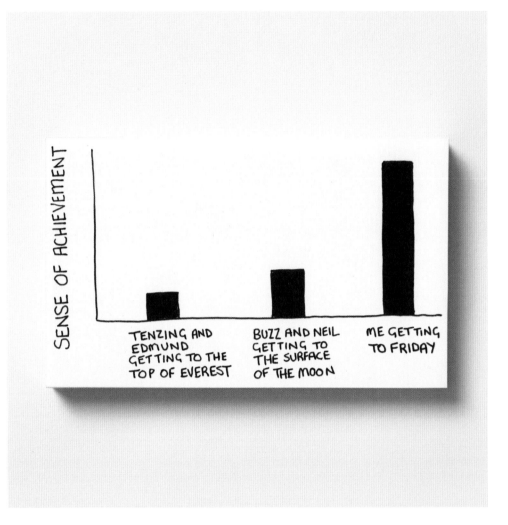

Coincidently enough, Edmund and Tenzing arrived at the summit of Mount Everest just before lunch on a Friday. Meanwhile Buzz and Neil didn't arrive on the Moon till Sunday, having left for work the previous Wednesday, which, along with a few other notable records, still stands as the world's longest commute to work.

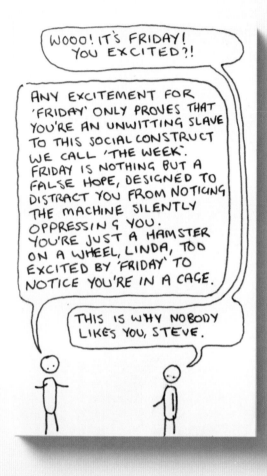

'Steve's not coming for lunch because he refuses to be oppressed by organised meal times.'

HOME

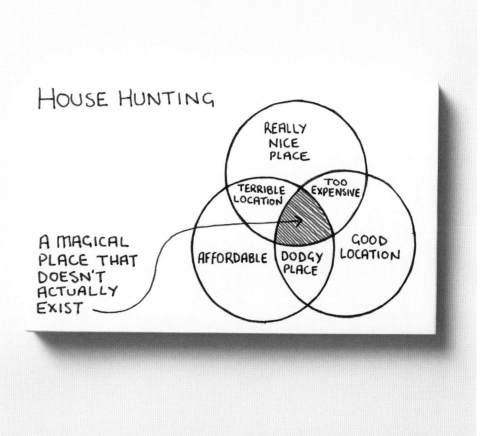

Here's the thing. It's not about finding a place that fits all the right criteria, but rather finding a place where you're willing to put up with the one criterion it doesn't fit. Do you want an hour-plus commute to work? Or do you want to pay three-quarters of your pay cheque on rent? Because if you answered no to either of those, then you'd better be happy living in the kind of place where you sometimes consider committing a serious crime because a prison might be a nicer place to live.

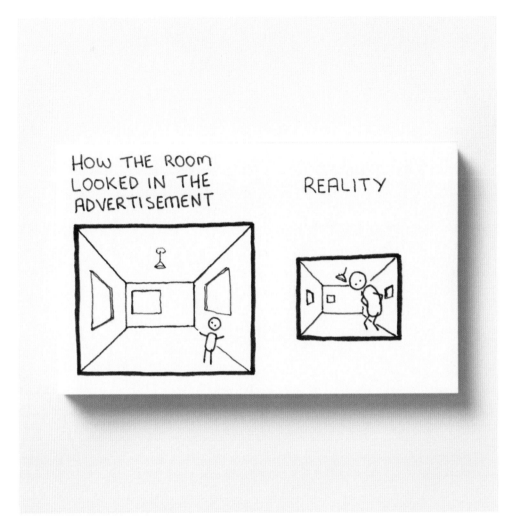

'Aaaah, okay, so that's just a painting of a window on the wall, which isn't even a wall, but rather a curtain you've put up cordoning off a section of your living room; all of which makes your advertisement for this "room" extremely misleading. However, I will obviously take it.'

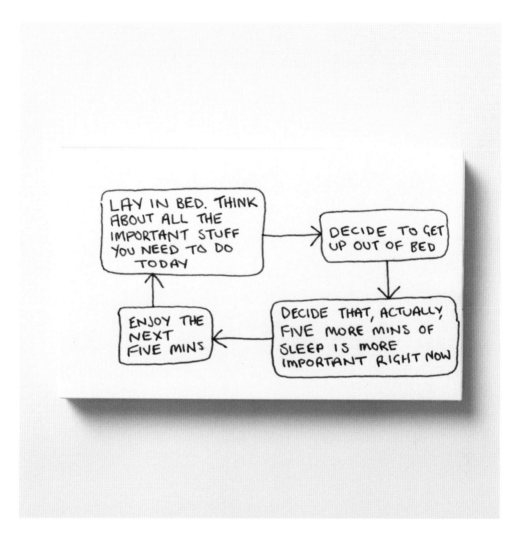

'Okay, if I skip a shower, skip breakfast, don't bother ironing my shirt and get a taxi to work, that probably gives me another 45 minutes of sleep time. Sure, I'll look vaguely homeless on arrival to work, but I'm pretty sure it'll be worth it.'

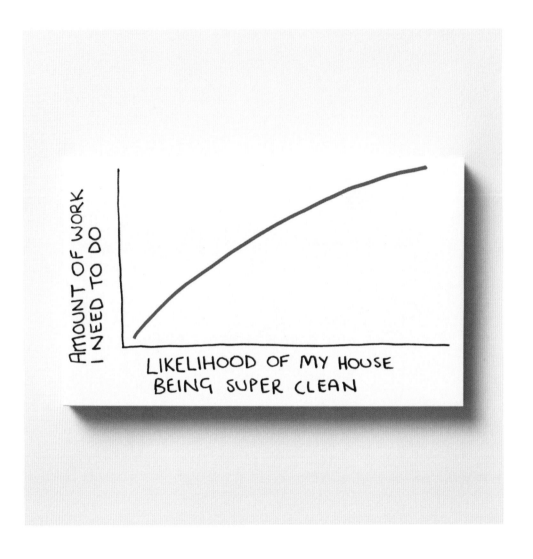

I wonder what cleaners do to procrastinate.

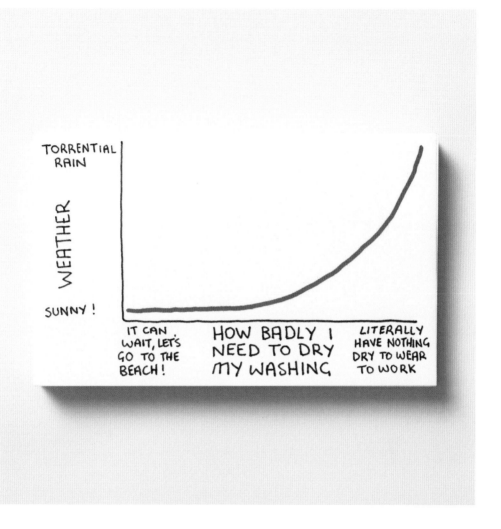

If there's ever a drought, the entire population should just get together and all put on some washing at the same time, then just sit back and watch the clouds roll in as a million washing machines across the country collectively hit their spin cycle.

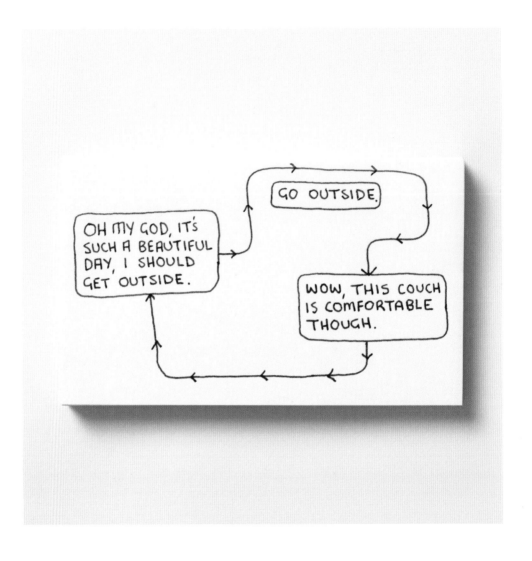

'Ideally, I'd like a house with large windows that the sun can shine through and under which I could position a couch, thereby gaining the benefits of the "amazing day" your friend's text message claims is happening outside your front door, but also not having to leave the house.'

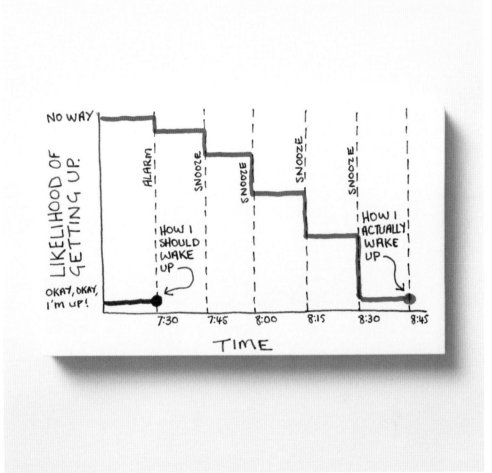

The entire world seems to have the same attitude towards dealing with climate change. Sure, we should do something ... in a little bit.

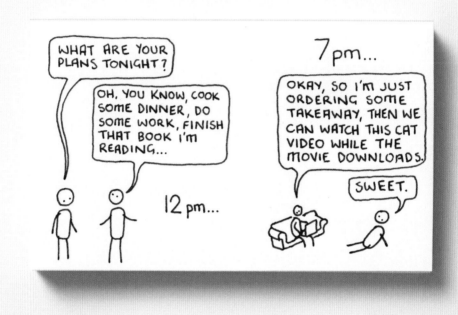

'Wait, wait, wait, we need to watch *The Talking Boat*, too – just search for it on YouTube, trust me ...'

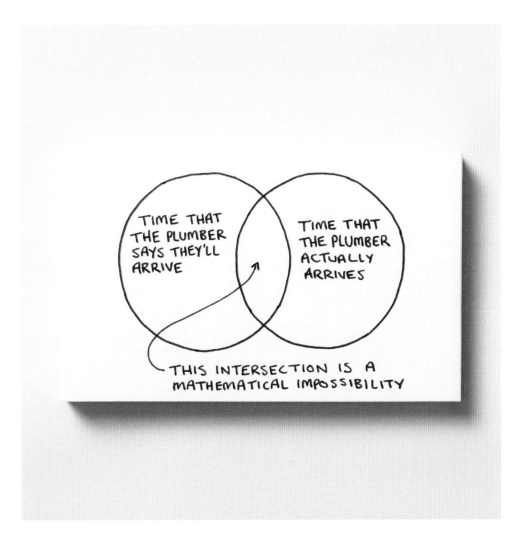

If only baristas operated on the same laissez-faire attitude towards making coffee, then I could call work and tell them that *I'll be in sometime between 8am and 1pm, I'm just waiting for a coffee. Really sorry, but it's the only time they can make it,* and then I'd just hang out in the café all day, cursing baristas.

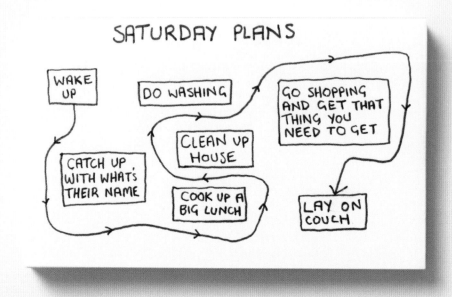

'Not doing stuff' is one of my favourite things to do on the weekends. It also means I'm unable to do a lot of other things because 'not doing stuff' seems to take up a lot of my time. I'm very busy like that.

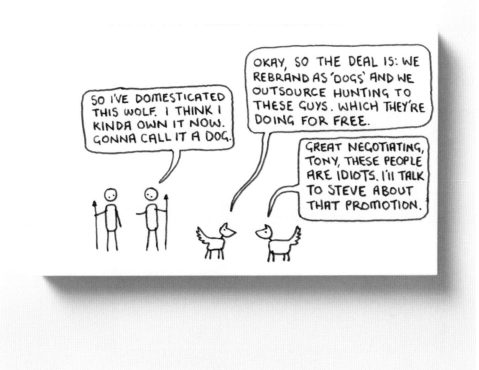

'Yeah, I'm pretty excited about it. With any luck we'll no longer need these hunting and survival skills, and within a few millennia and with a bit of selective breeding we'll finally achieve our dream of being no bigger than rats and getting carried around in handbags. I'm telling you, this merger is the best thing we've ever done.'

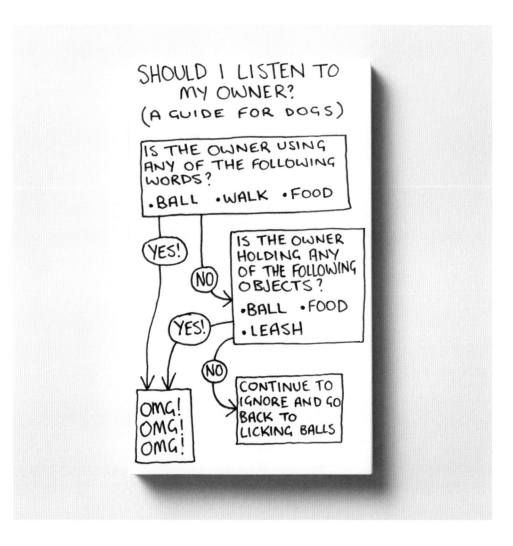

Wait, has someone new arrived in the house? Yes? In that case, do a whole lot of barking and running about, and then go eat some food for no discernible reason other than to prove that you're good at all kinds of stuff, like eating.

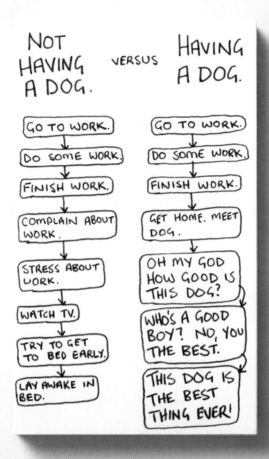

Sometimes I wonder if dogs actually love us or if they've just realised that if someone follows you around and picks up your poo, then you shouldn't upset that person because they are clearly insane.

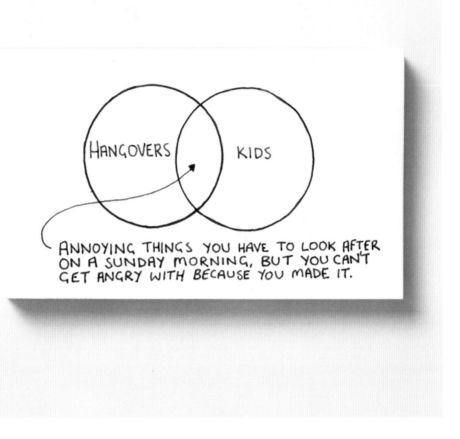

HANGOVERS

KIDS

ANNOYING THINGS YOU HAVE TO LOOK AFTER ON A SUNDAY MORNING, BUT YOU CAN'T GET ANGRY WITH BECAUSE YOU MADE IT.

Some people think getting a dog serves as good practice for having a kid. But in reality, having a dog is a far bigger responsibility – for a start, kids won't maul your neighbour's cat to death if you let them out of your sight for five minutes. No, the far more responsible option is to get horribly drunk as much as possible and get good at looking after hangovers as if they're annoying, needy, miniature people.

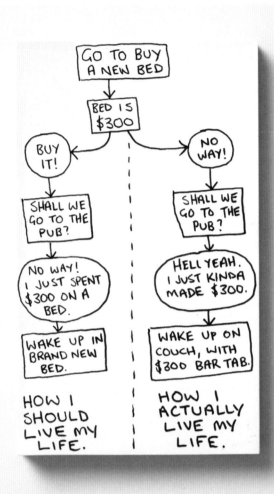

I can also justify buying takeaway rather than cooking with this simple equation: calculate the amount you'd get paid over the time it would take you to cook your own dinner, then calculate the difference between that and the cost of takeaway and with any luck you're actually making money by ordering takeaway.

I know, genius. Right?

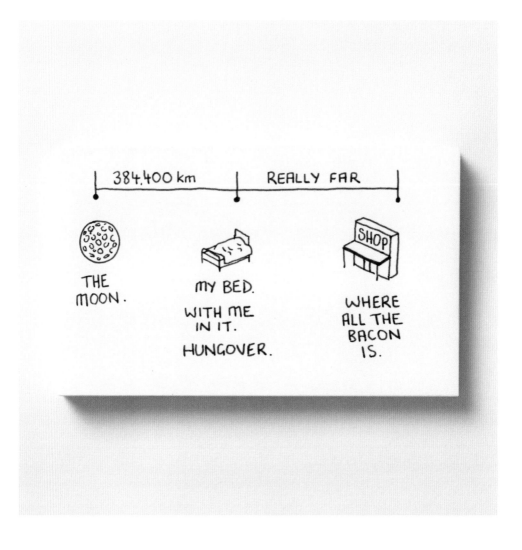

It took Neil Armstrong and Buzz Aldrin about eight days and about $100 billion in today's money to get to the Moon and back, and after all that they didn't even return with any bacon or delicious drinks. Which begs the question, just what was the point of going to the Moon?

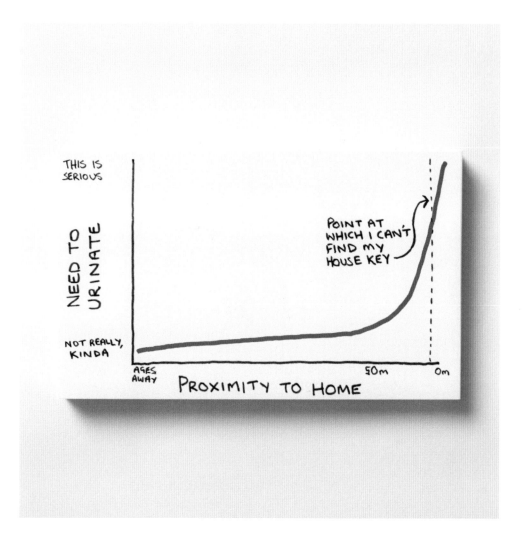

'Seriously, Gary, you reminding me that I should have gone when we were still at the pub is NOT HELPING THE SITUATION RIGHT NOW.'

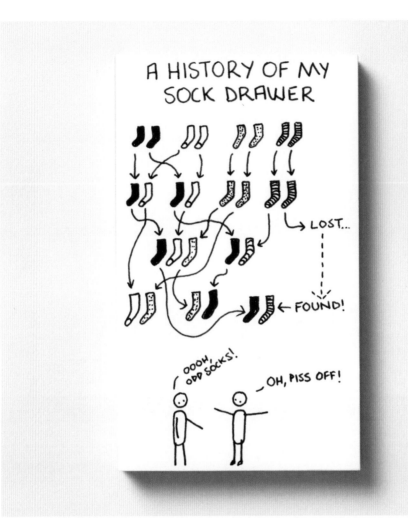

Can someone make an Ancestry.com for socks? I want to know what happened to the other half of that big old fluffy pair of sports socks. I wonder where it ended up. And if it looks to the sock-drawer heavens each night, praying that one day it will be reunited with its other sock, completely unaware that its partner has since teamed up with another sock-widow and the two now make a very happy, albeit entirely odd, couple.

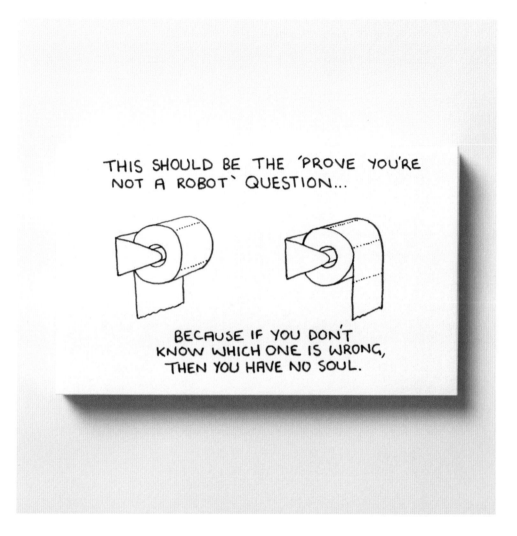

And don't think I'm about to give you the answer. You'll just have to live your life knowing that there's a 50 per cent possibility you're a robot.

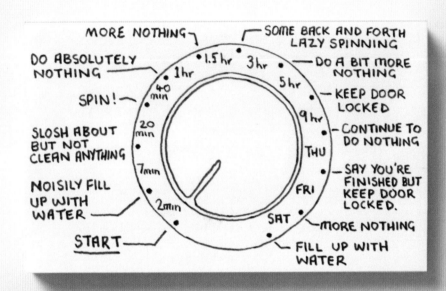

I'll be honest, washing your clothes isn't the most entertaining chore, so having to engage in negotiations with a machine that's holding your clothes as if they're a bunch of hostages makes the whole experience a lot more exciting, albeit occasionally infuriating. I honestly feel that after washing my clothes in dodgy washing machines for the last 15 years, I'd make a pretty good hostage negotiator should the situation ever present itself.

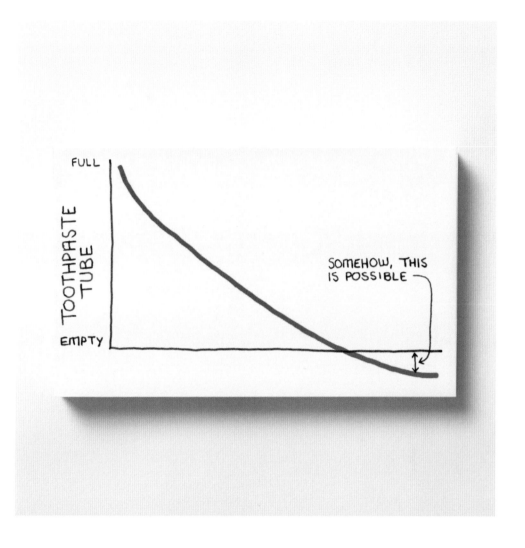

There are several theories on the ultimate fate of the universe. One of them predicts that eventually it will run out of the gas needed to power stars, which in turn will all burn out, leaving only black holes that will gradually consume each other as the universe slowly approaches maximum entropy, leaving an empty, dark, silent vacuum devoid of anything.

Except, of course, for a little bit of toothpaste left over.

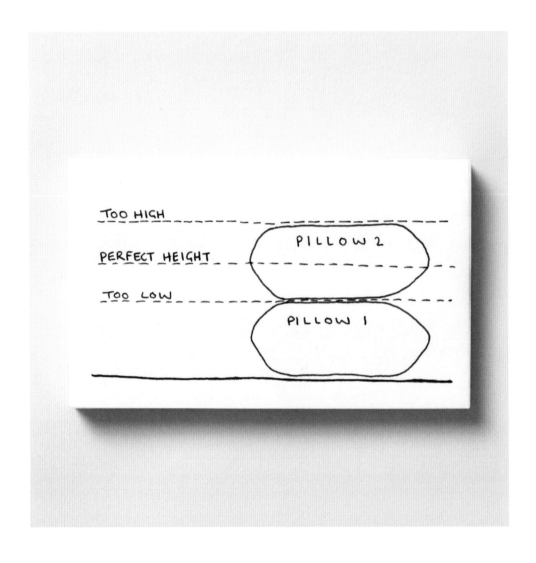

I'm now almost entirely convinced that this is just an ongoing joke in the design department at the pillow factory. Well played, pillow designers, well played.

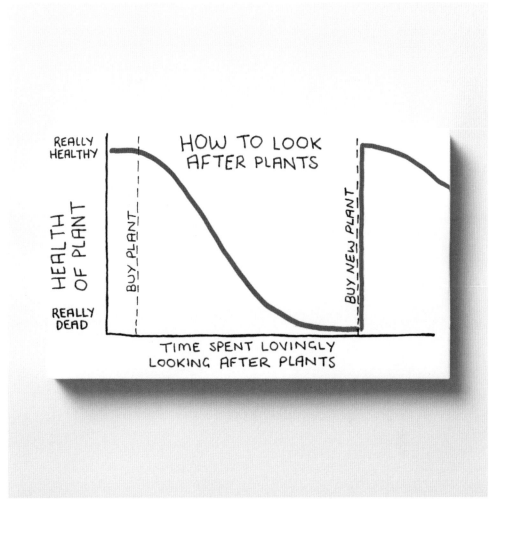

'Oh, you grow plants?'

'Ummm ... well, I have plants and they're alive, for now.'

'So ... you grow plants, then?'

'I prefer the term "caretaker". I kind of just make their lives comfortable before their imminent death.'

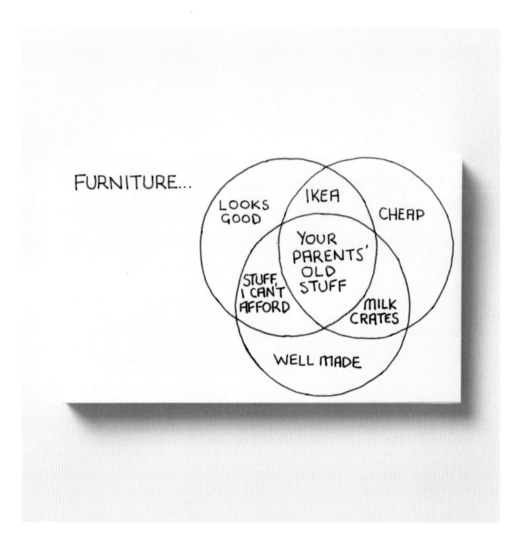

Sadly, I doubt the mixed-up mess of chipboard and dowel that is my furniture will be in any state to pass on to anyone. In many ways, being able to construct Ikea furniture will become the forgotten skill of our generation, one that we'll make our children attempt while we watch them with a look of disgust as they struggle to decipher it all, in the same way our parents did to us as we attempted to use a rotary phone, put a vinyl record on or stay in the same job longer than three years.

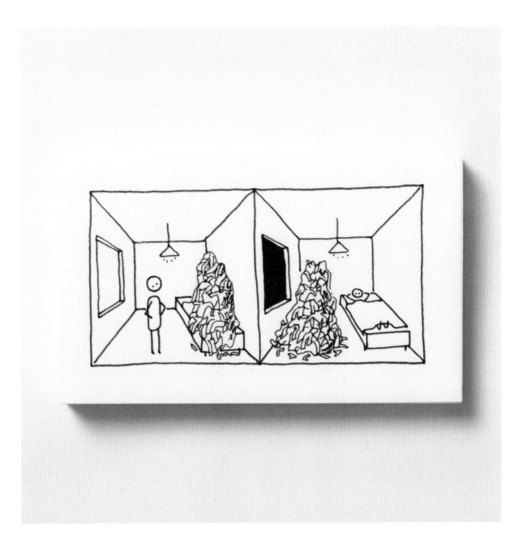

Why does anyone bother with a wardrobe when you can utilise this far more ephemeral, fluctuating wardrobe that's less a physical object and more an obscure concept? If anything, it's certainly a lot easier to put together than anything from Ikea.

ENTERTAINMENT

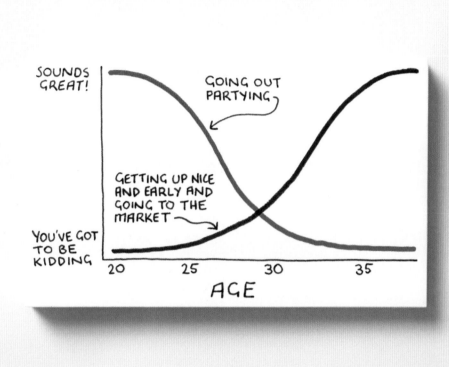

There's a moment in life when you're at a nightclub and you look around the seething mass of sweaty people rubbing up against each other while they scream into each other's ears over the noise of a truly terrible song, and you think to yourself, *I am too old and uncool for this, and I am cool with that*. And as soon as you have that thought then it's time to get your canvas bags and your shopping list and set your alarm for nice and early.

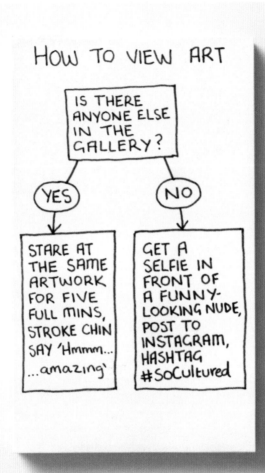

Always remember that at some point in their lives even the most revered and respected art critics probably had a little giggle over some nudity. Now, with that in mind, go forth into that ostensibly serious world of art and point and laugh, safe in the knowledge that you're extremely cultured.

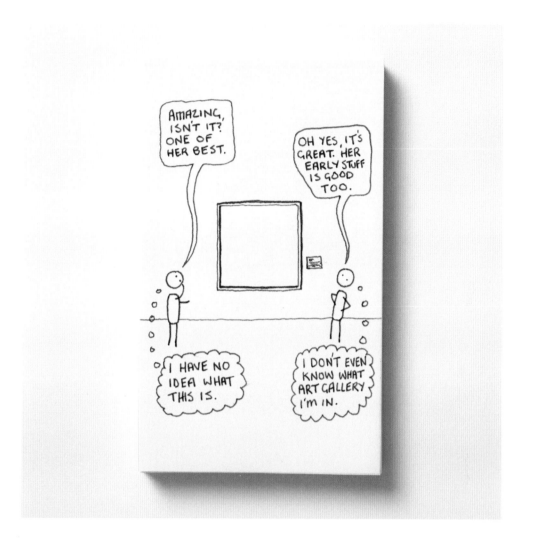

Some art gallery viewing tips. Speed is key. Try not to walk through the gallery too fast and keep up that contemplative face, then maybe stand in front of a particularly confusing work for a while and slowly shake your head as if you're blown away by the technique or the idea or the whatever. Then do some more slow walking and inquisitive looks and with any luck you should be starting to look like someone who knows what they're doing there, and you'll be more or less unrecognisable within an entire crowd of people doing exactly the same thing.

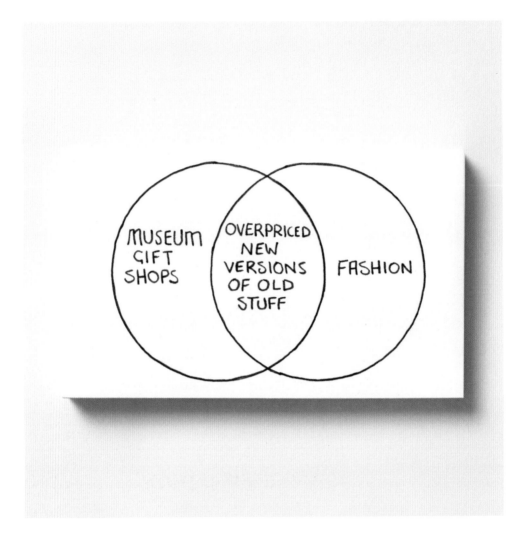

I think everything should have a gift shop. After you leave a pub you could leave via the pub gift shop and buy a miniature local drunk guy to put in your own house as a little reminder of that pub. People would say, 'Where'd you get that local drunk guy?' And you'd have a little laugh and explain, 'Oh, it's not a real local drunk guy. I just picked him up from the pub gift shop! But you should go see the real thing, though. It's worth seeing for real.'

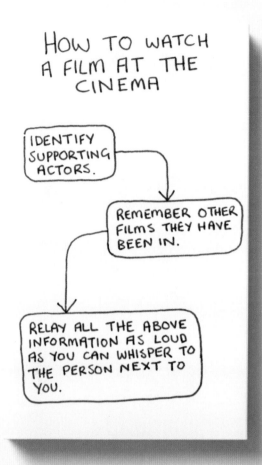

There's a special kind of satisfying joy when you suddenly remember what other film that actor was in, so you loudly tell your friend and then get kicked out for being loud, and on the way out someone reminds you that it's Paul Giamatti and that he's in every film ever so it doesn't actually count.

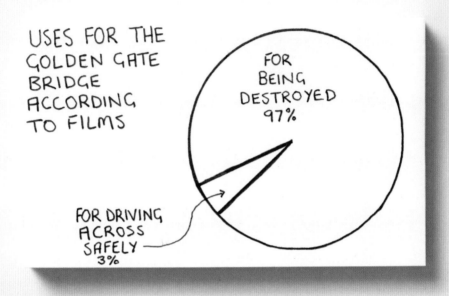

USES FOR THE GOLDEN GATE BRIDGE ACCORDING TO FILMS

FOR BEING DESTROYED 97%

FOR DRIVING ACROSS SAFELY 3%

Al Zampa was a bridge builder who worked on many of the bridges around San Francisco and is also famous for being one of the first people to survive falling off the Golden Gate Bridge during its construction. Turned out Al wasn't very good at dying and eventually lived to the ripe old age of 95.

At some point they even named a bridge in his honour, which is a bit like naming a new species of shark after a shark attack survivor, when you think about it.

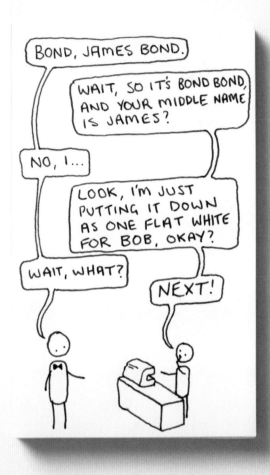

You see Bond drinking a lot of Martinis, but you never see him struggling out of bed the next day and sucking down three espressos. There's no way you're getting up the next morning after even two Martinis and engaging in car chases and general badassery without at least a decent coffee or two to get things going.

And by 'get things going' I'm talking about bowel movements. Another side of Bond you never see. Just once I'd like to see a scene where someone goes, 'Quick, Bond! We gotta go!' and then Bond casually picks up a magazine and says, 'Cool, just give me five, I'll be right with you.'

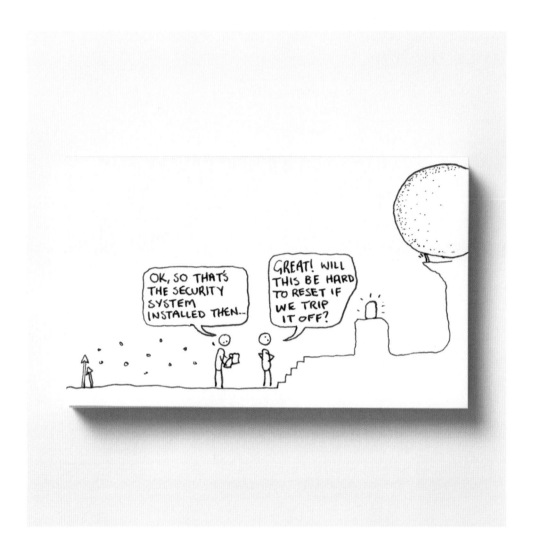

What the hell happened after Indiana Jones stole the idol, anyway? Were the owners compensated by the security guy? Did they leave a bad Yelp review? Did the fact that a US archaeology professor blatantly stole another country's priceless artefact at all affect the traditionally rocky bilateral relations between Peru and the United States? There's just so many questions that *Raiders of the Lost Ark* fails to answer.

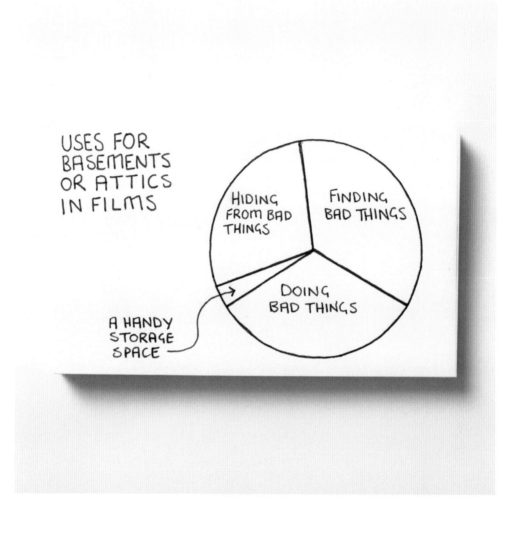

I'd love to see a scene in a film where someone goes into an attic or basement to retrieve something like their golf clubs or a box of VHS tapes (or whatever it is people put in basements and attics) and absolutely nothing happens while they're in there.

And you know what? You'd still leave the cinema and say to your date, 'Yeah, but what about that basement scene – what did that *really mean*?'

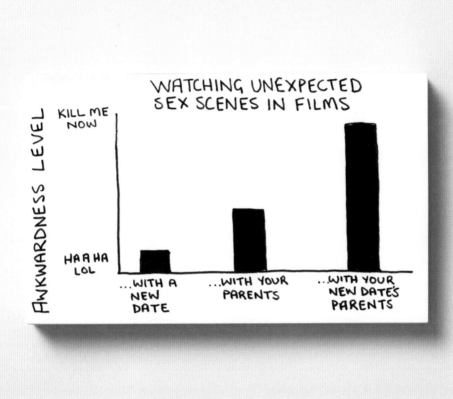

'I'm just going to go make some tea – anyone want some tea? No? Okay, I'll go make some tea.'

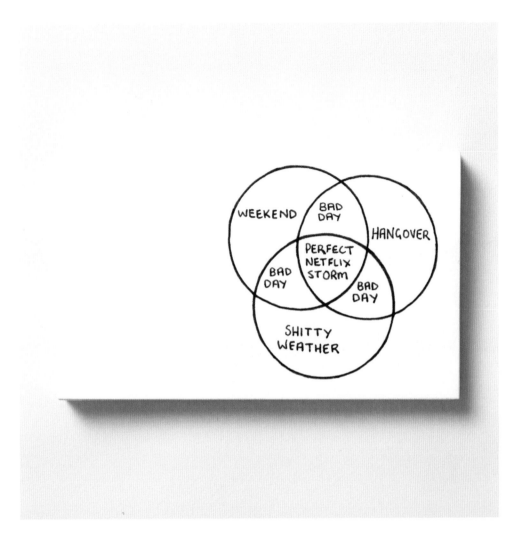

Sometimes three wrongs make a right.

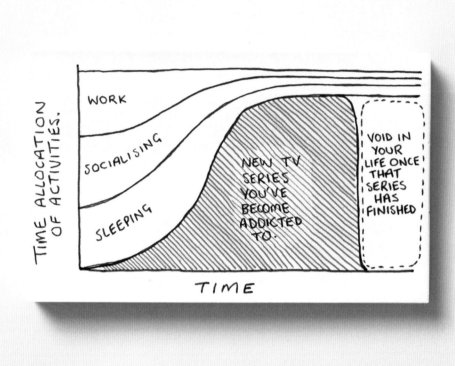

Sure, you could fill that void left by *House of Cards* with French lessons or pottery classes or maybe completing an MBA or becoming a doctor or ... or you could start scrolling through the uncharted backwaters of Netflix trying to find something, anything, to watch, like the desperate television-addicted junkie you are.

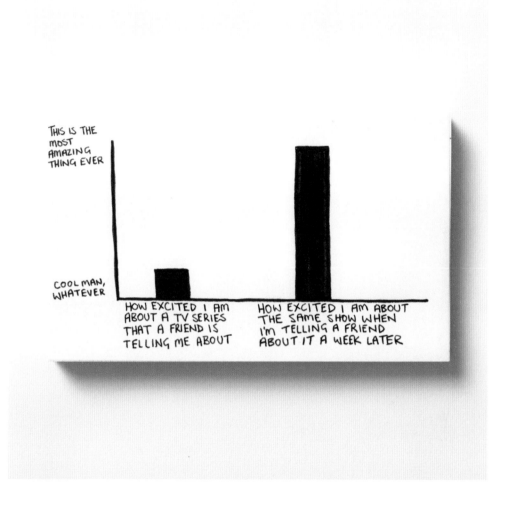

'... so, it's like *The Wire*, as in it's very Shakespearean, but also like *Breaking Bad* with an overarching character development that drives the show, but the cinematography is on a par with *House of Cards* and its subdued yellow and blue palette, so there's this consistency really pulling the whole thing together, and wait ... hey ... why are you walking away from me?'

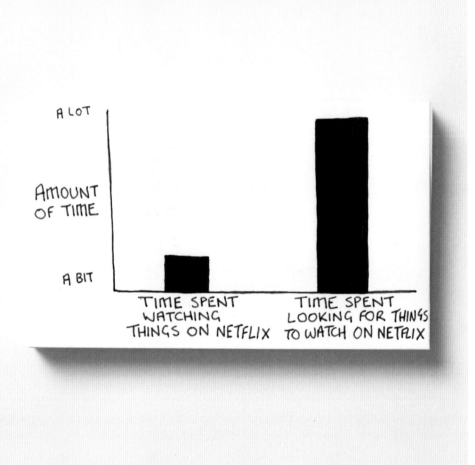

I remember back in the days of VHS tapes, there were always two or three trailers you'd need to watch before the main feature came on. And whenever that happened, you'd always think to yourself, *Wouldn't it be cool if there was just a whole video of non-stop trailers*? Well, the future is finally here, everyone. You can watch Netflix trailers all day and never commit to anything, employing much the same attitude you have to your career. How good is the future?

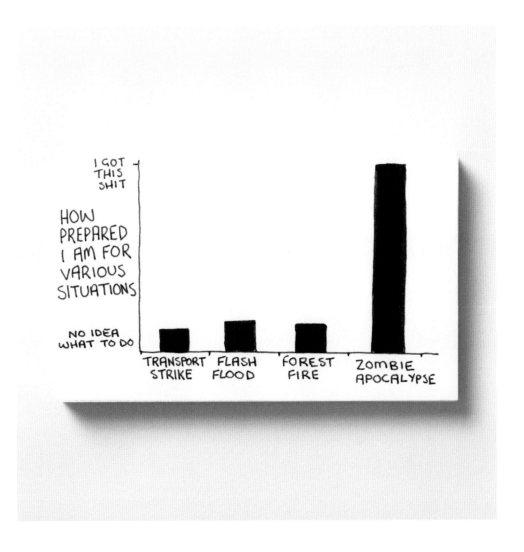

If there were popular TV shows and movies about public transport strikes, floods or fires then I might be more prepared for them, but as it stands I feel like I've spent the last decade studying to become an expert for an extremely unlikely situation (which is not that dissimilar to my university degree).

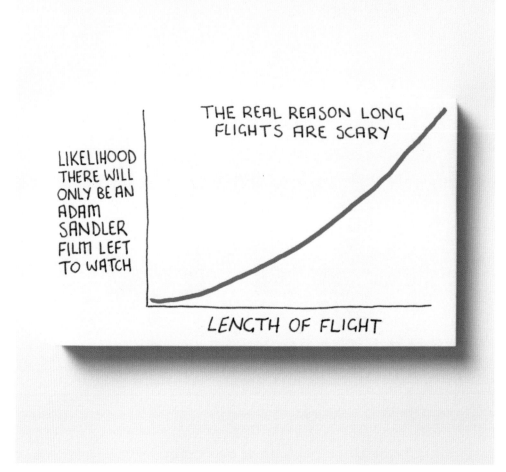

While flying from Australia to the UK, it's often during the 19th or 20th hour of the flight that my brain reaches a certain level of exhaustion where a 90s Sandler film is about the only kind of idiocy it can deal with. Thanks, Adam.

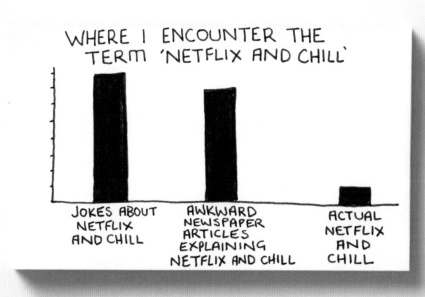

One day we're going to have to explain to our grandchildren what 'Netflix and Chill' was, and the explanation is only going to reinforce your grandchild's opinion that the 2010s must have been a strange and baffling time to live in. Either that, or they'll just assume their grandparent is making up more fanciful stories about the past, like that time they tried to convince them that people used to take photos of their own faces and then put them onto a thing called Instagram in order to obtain an imaginary and worthless currency called 'likes' for no discernible reason whatsoever.

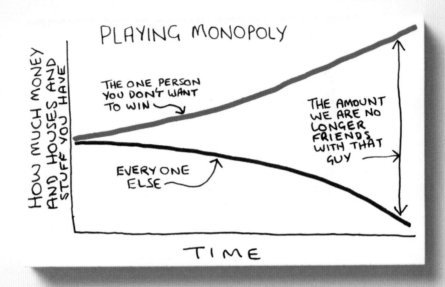

Monopoly needs to be more realistic. For instance, if you buy Old Kent Road at the start of the game, then by a few moves that terminally cheap street should have converted into trendy coffee shops and organic grocers and be twice as expensive as Mayfair. Then all the artists who were living there originally would get squeezed out by the higher rent and move in to one of the train stations, which at that stage would have closed down thanks to budget cuts and been converted into a community artist space.

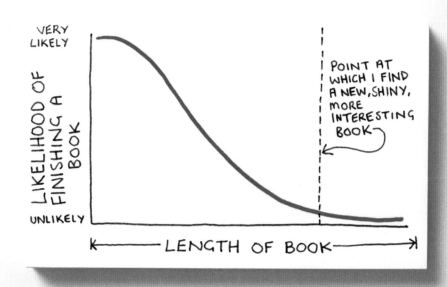

It's okay, I don't expect you to finish this one either.

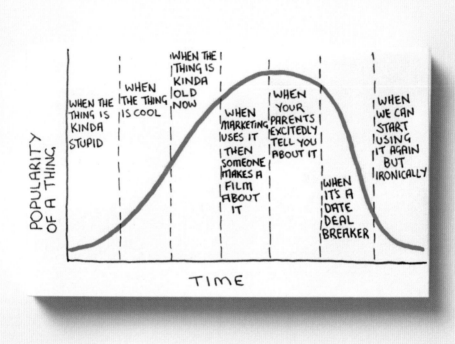

If you ever see a marketing company using this graph, you'll know what's going on.

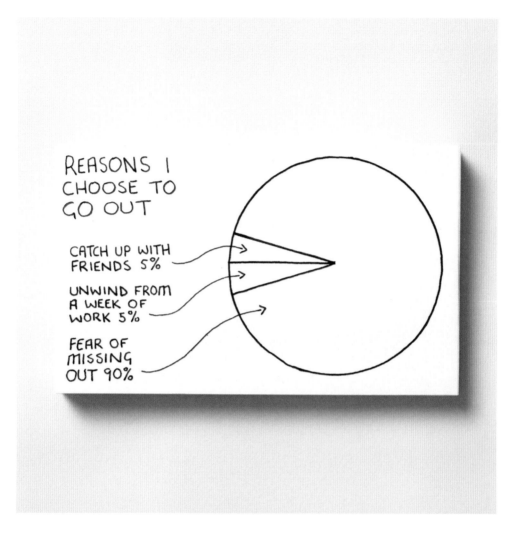

'No, I think I'm going to just stay in tonight ... Who's even going out? ... Oh, everyone?... Oh, God! ... Okay, I'll see you in half an hour.'

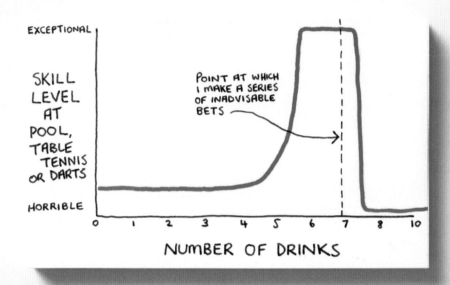

I wish the same kind of skill curve could be applied to my professional career.

'Chaz, we need you to start on this difficult new project.'

'No worries, just let me get to the end of this fourth pint and I'll be ready to take that on.'

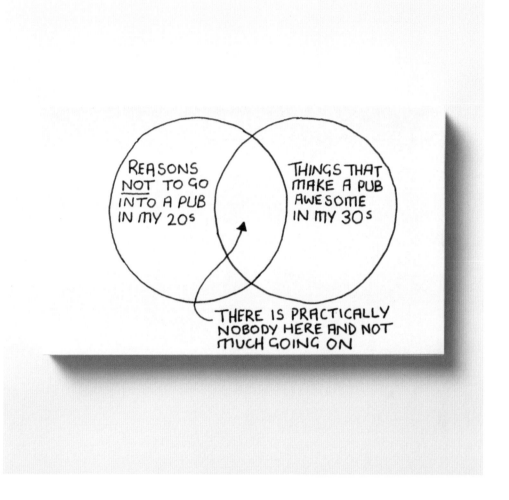

20s: 'Guys, come on, there's nobody in here.'

30s: 'Guys, come on! There's nobody in here!'

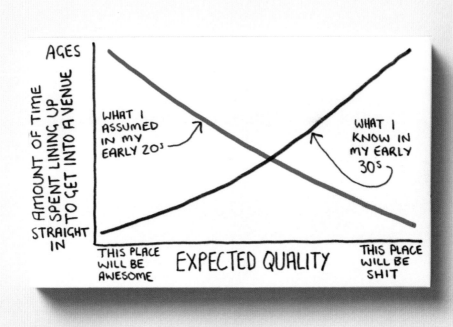

Given that queues for bars are generally engineered by the bouncer to create the illusion of a presumably wildly successful venue behind its closed doors, what you're really doing in that queue is participating in a large-scale street-performance art installation. So on the downside you're just an unwitting advertising tool, but on the upside you're an artist.

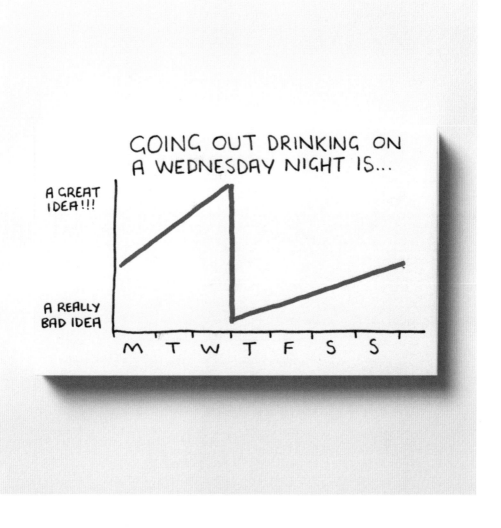

5:30pm: 'We'll just have one or two, you know, nothing crazy. We have that super-important meeting tomorrow, after all ...'

2:00am: 'We didn't have anything important to do tomorrow, did we? I can't remember. I think it'll be fine, though. Let's have these shots ...'

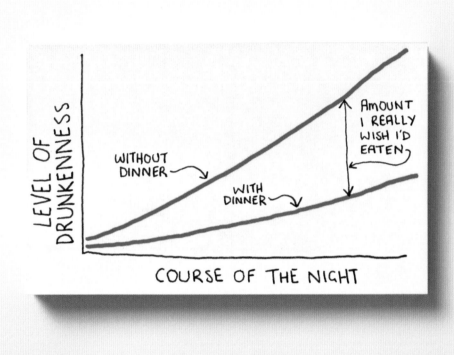

There's usually only a short window to get this right, as it only takes about two and a half drinks to convince myself that a small packet of crisps and a pint of Guinness are more or less the equivalent of a proper meal.

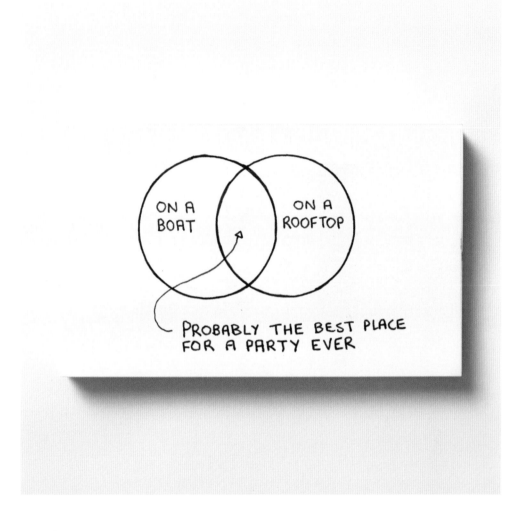

Maybe it's the chance of death by falling or drowning that's always a possibility. Because there's nothing like the real chance of death nearby to really kick a party into gear, right?

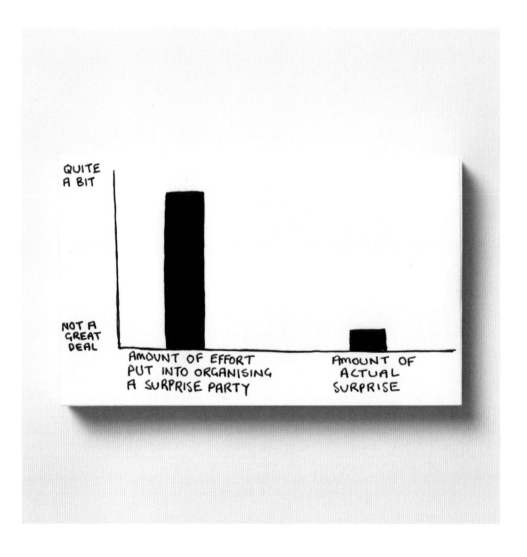

There's a moment. It's very brief, but it's ever so beautiful. It lasts for just a few sweet seconds; it starts right after everyone collectively finishes yelling 'Surprise!' and lasts right up until the feigned surprise of the person apparently being surprised. And it's during those few sweet seconds of brief silence where it occurs to everyone that all the thought and effort and clandestine organisation that went into this highly elaborate ruse just really wasn't worth the pay-off.

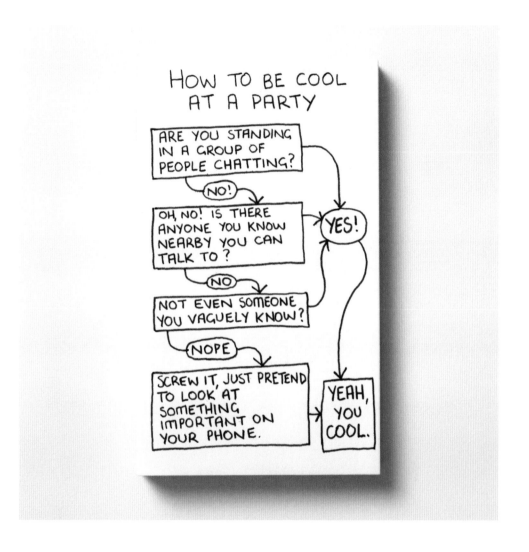

Once you've pretended to use your phone for longer than it takes to check your text messages, email, Facebook, Twitter, Snapchat, Instagram and Tinder and rate last night's Uber ride, then you're going to need to leave.

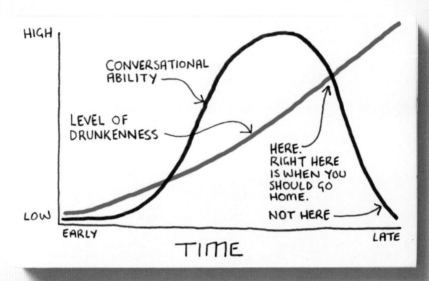

Frustratingly, there's another line on this graph that I haven't drawn that starts quite high and gradually decreases entitled 'Ability to realise the point at which I should go home'. Who'd have thought going out could be so mathematically complicated?

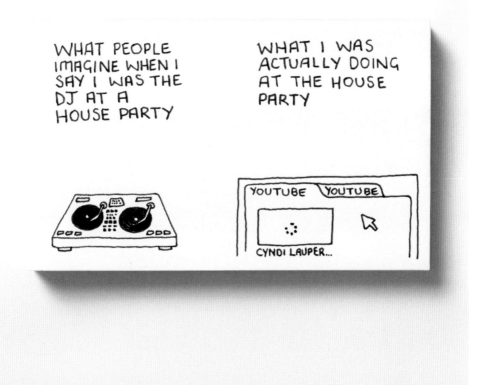

WHAT PEOPLE
IMAGINE WHEN I
SAY I WAS THE
DJ AT A
HOUSE PARTY

WHAT I WAS
ACTUALLY DOING
AT THE HOUSE
PARTY

YOUTUBE YOUTUBE

CYNDI LAUPER...

Arguably, running six different YouTube tabs, while ensuring the sound is down on the next video during the ad before it plays, then timing that in with the end of the previous video and turning that down before it automatically plays the rest of the *MJ's Greatest Hits* playlist, while ensuring that you're streaming the minimum amount in order not to have the whole thing hit a buffer zone just before 'Like a Prayer' kicks in, subsequently making you the most hated person at the party ... is actually a pretty amazing skill and one that I feel is entirely overlooked by real DJs.

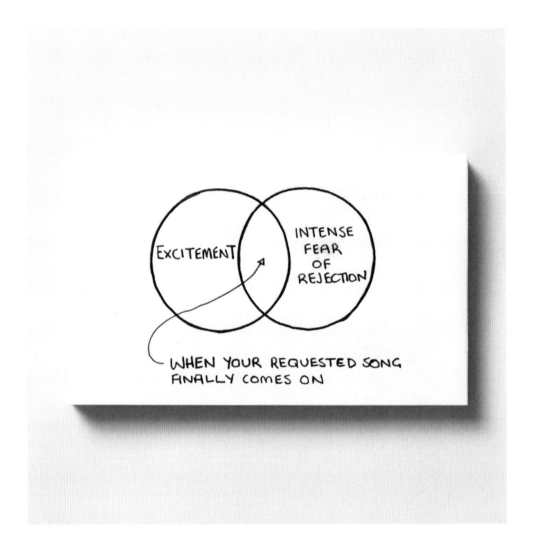

'You can change it if you like, you know ... like, I don't mind – I'm like totally cool or whatever – Oh? You like it? Yeah – I totally chose this, I love it ... Yes, I agree, I'm quite a good DJ.'

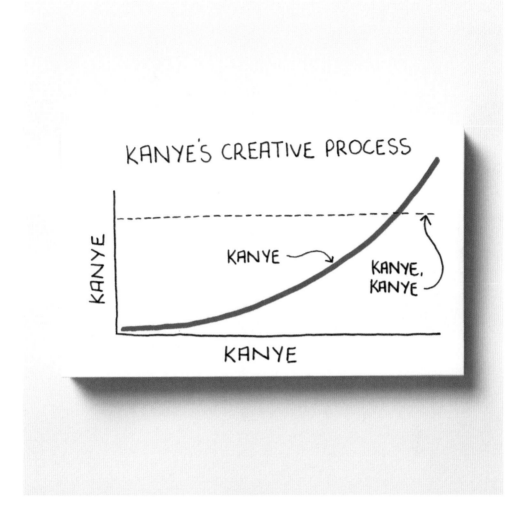

Which came first, the Kanye or the Kanye?

'I'm next to the guy with the hat! ... No, not that hat, the other hat ... okay, see the red tent on the right-hand side of the stage? ... Okay, if you draw a line between the blue tent and the tree near the hat guy, then we're one-third along that line but a little bit perpendicular to that line ... No, you're thinking of parallel; perpendicular is like a right-angle from the line ... Because perpendicular is a much better word ... Okay, I'll stay here until you happen to walk past us by chance.'

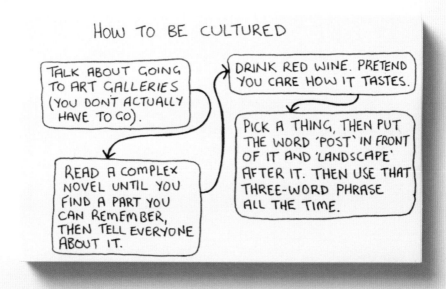

This has served me surprisingly well while navigating a career where one encounters quite a bit of red wine and exhibition openings – especially, of course, one rooted in a post-Kantian landscape.

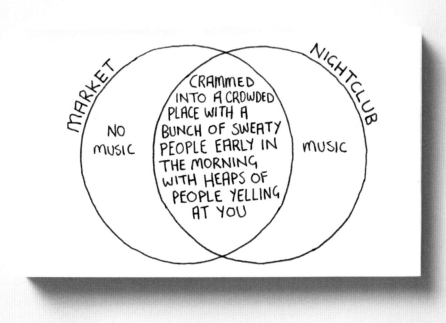

Let's not also forget *a lot of people on the street trying to sell you questionable-looking food* or perhaps *everything is a bit more expensive than you were expecting* or even *a serious lack of toilet facilities considering the size of the crowd*. The difference between your 20s and 30s is really just a matter of location.

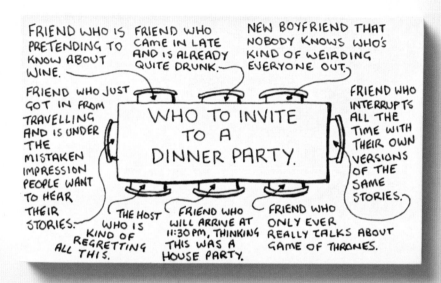

'No, trust me, I'm quite happy doing the dishes.'

FOOD AND DRINK

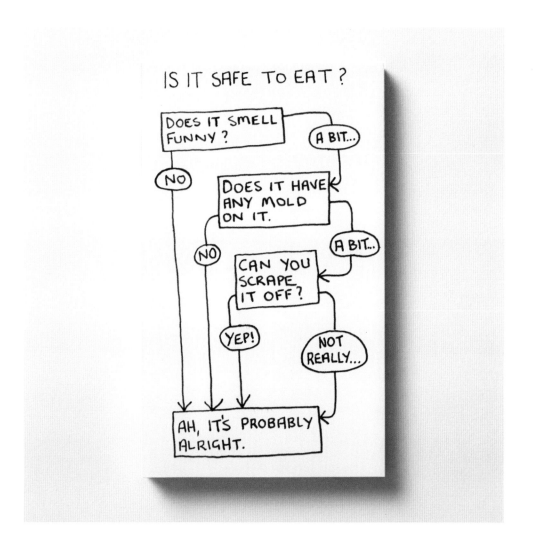

No, I don't know why I'm still single either.

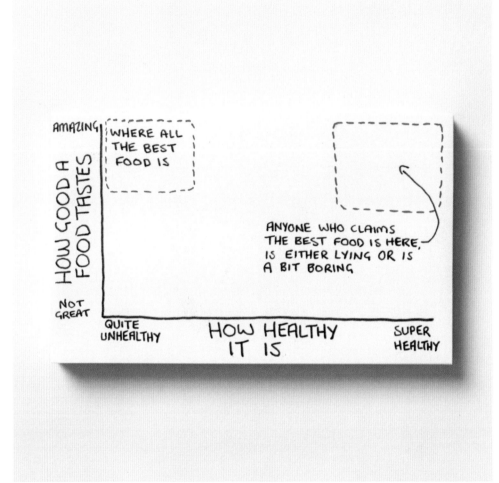

If there were a God, then pizza would obviously be a health food. Which means God either doesn't exist, or he does and he's a massive arsehole.

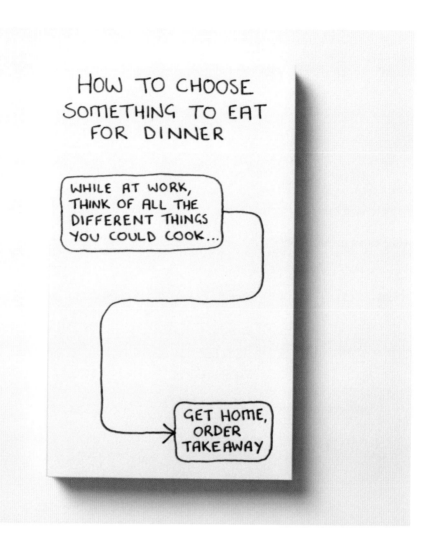

How am I supposed to not eat takeaway when I can get some delicious local Chinese for less than the cost of ingredients for any other dish I could try to cook myself? The way I see it, cooking for myself would be financially irresponsible.

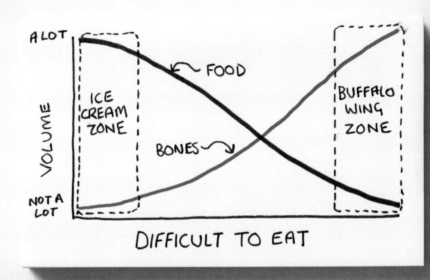

A local bar I used to frequent had an eating challenge where one had to consume 60 wings in 60 mins. People rarely managed it, and the record sat at 50 minutes for several years. That was, until a mysterious man arrived one day and set a record of 16 minutes. For the first 12 minutes, he sat there systematically pulling the bones out of the wings until he had two piles, one of bones and one of meat, the latter of which he then furiously consumed in just four spectacular minutes. He effectively flipped the above chart on its head, and the entire spectacle still stands as the most ingenious and outright disgusting things I have ever witnessed.

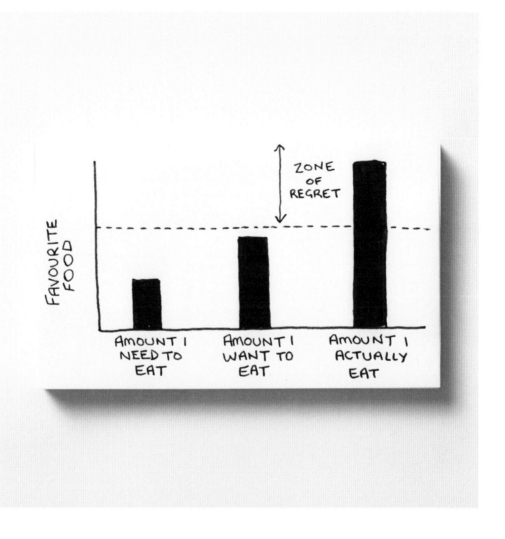

Stomach: 'You really can't eat any more.'
Brain: 'Yeah, seriously, dude, don't eat any more.'
Friends: 'Don't eat any more, man.'
Doctor: 'I highly advise you not to eat any more.'
United Nations: 'We've unanimously voted against this.'
Me: (long pause) 'Guys, I think I'm going to eat some more.'

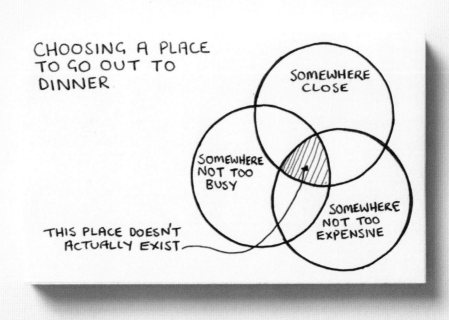

If you do find a good, decently priced restaurant, I highly recommend finding a house as close as possible and just moving in. Never mind that people might already be living there. I'm sure they'll understand if you explain this Venn diagram to them.

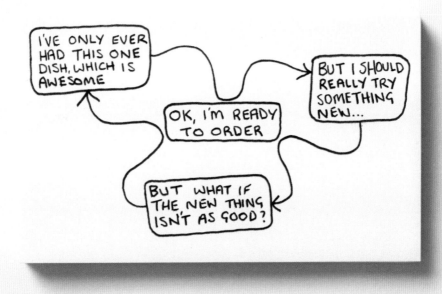

People say it's important to take risks, but these people have never had to eat a regretful meal choice while staring across the restaurant at a person eating the amazing dish you usually get. Moral of the story: don't ever go out on a limb and try something new, especially when it comes to food.

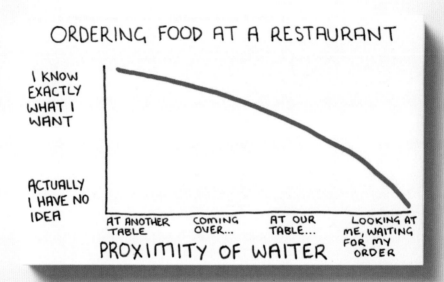

That moment when you've known what you wanted this entire time and it's your chance to make that decision, and you realise that no, this is all wrong; everything you thought you wanted was wrong, and you're going to have to start all over again, and you have no idea what to do, and you're pretty sure it's too late to start again.

No, I'm not talking about ordering in a restaurant any more. This is real life.

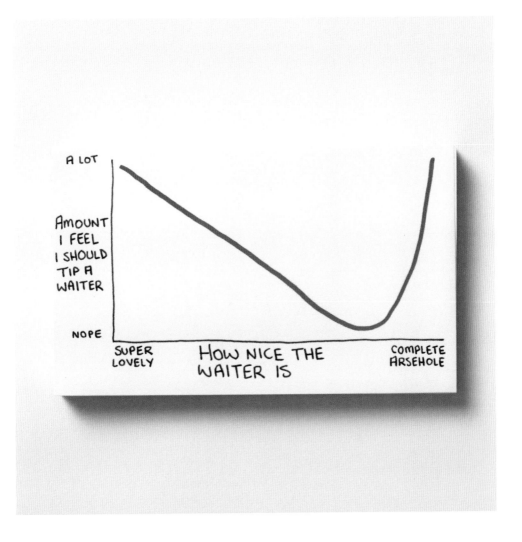

Trust me, we can buy their love.

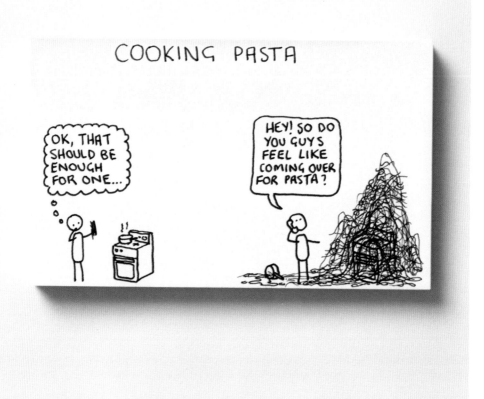

I always get this wrong, but I'm still too cautious to risk cooking too little. Is this a life metaphor I should be taking note of?

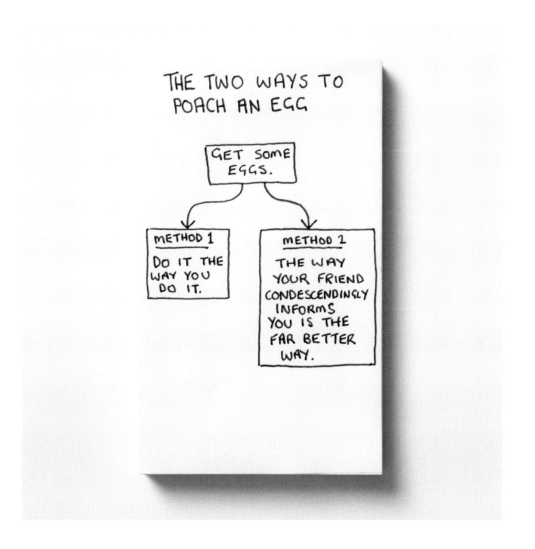

'Oh dear, you poach your eggs in boiling water? No, no, no, the BEST way is to poach them in 86°C pH-neutral water during a Full Moon to ensure consistency. I mean, I thought *everyone* knew that.'

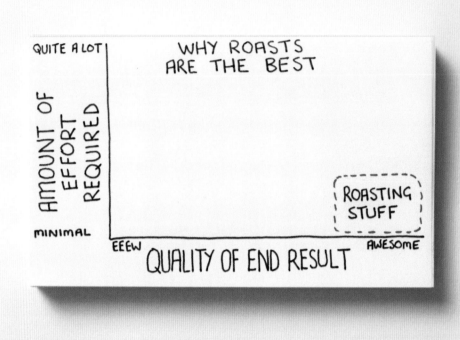

I was always impressed by my parents when they used to cook up a big Sunday roast, but via my own experience as an adult I now have cause to believe there's a chance they might have just been a bit hungover and a roast seemed like the most effortless, low-energy thing to cook, while simultaneously being the best remedy for a hangover, all while hiding behind the guise of being quite a wholesome family activity.

Bravo, parents, bravo.

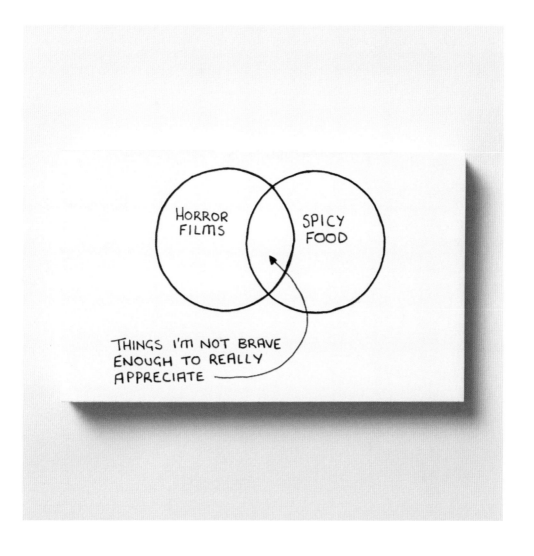

Boxing is also an art form, but I don't particularly enjoy getting repeatedly punched in the face, so I generally avoid doing it. I've got the same attitude towards horror films and spicy food, so I also try to avoid these. However, when you explain this to fans of horror and spice they look at you as if you've just said you hate puppies or quite like Coldplay. This look is more than I can take, so when offered some horror or spice I just pretend I'm into it and strap myself in for a few metaphorical punches in the face.

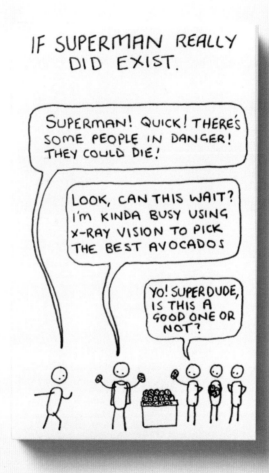

Let's be honest, Clark Kent can't afford to be Superman. Maybe he could have back in the 50s when journalism paid, but these days he'd be too overworked to have time for fighting crime, and frankly his pay cheque wouldn't cover standard superhero expenses like suit repair, hair gel and regular gym sessions. Which is why in my new script for the next *Superman* film, he gets a job in Whole Foods as an 'avocado whisperer'.

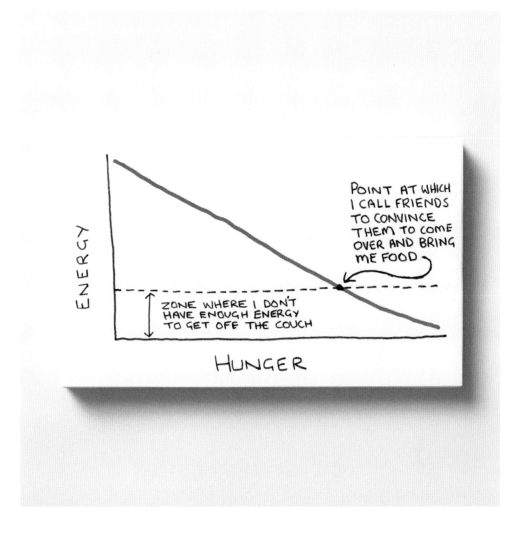

Sometimes I think about how I'd go if I was lost in the wilderness and had to somehow survive, Bear Grylls style. I like to think I'd do okay, but I often ruminate over this hypothetical situation while I'm lying on my couch, lacking the required energy to bother feeding myself in my own house, and I realise that no, being lost in the wilderness is probably not going to go well for me, which is why I make a point of never leaving cities or straying too far into parks.

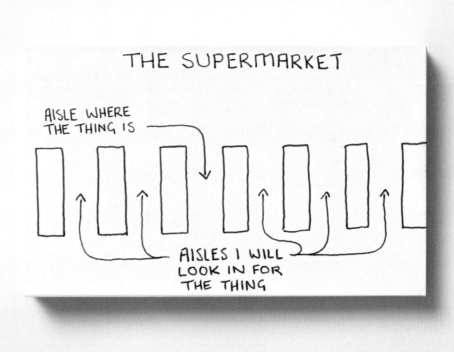

When I was 14 I used to work in a supermarket. It wasn't a big chain one; it was one of those old-school ones – you know, *independent* – which as well as meaning it was super-genuine and amazing, also means it no longer exists. I used to stock shelves for a hefty $6 an hour, along with another kid who used to open every box with a box cutter – until he opened up a box of Pine O Cleen, slicing through three of the six bottles of potent cleaning fluid inside. For the next four weeks an intense wall of nauseating pine-flavoured fumes effectively turned aisle three into our own mini Chernobyl. Sometimes, as I walk through the big, soulless chain supermarket that eventually replaced it, I can still catch a whiff of that pine-flavoured nostalgia.

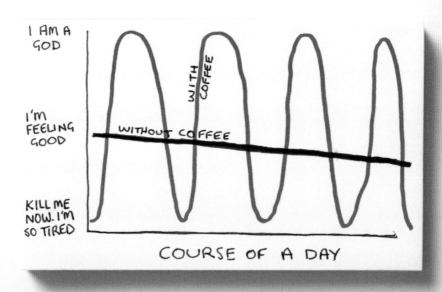

People will tell you that a green juice will deliver a much better, far more steady kind of energy release that is less likely to turn your kidneys inside out. However, these are the same people who will tell you that riding the teacups at the amusement park is just as thrilling as the rollercoaster.

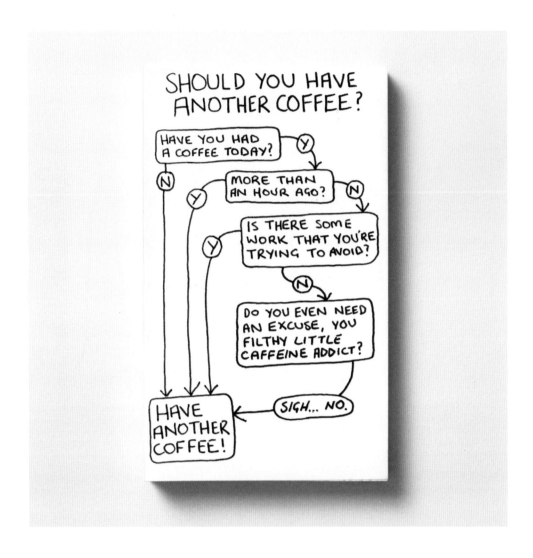

The only reason this book was able to be written is thanks to a strict adherence to the logic of this flow diagram.

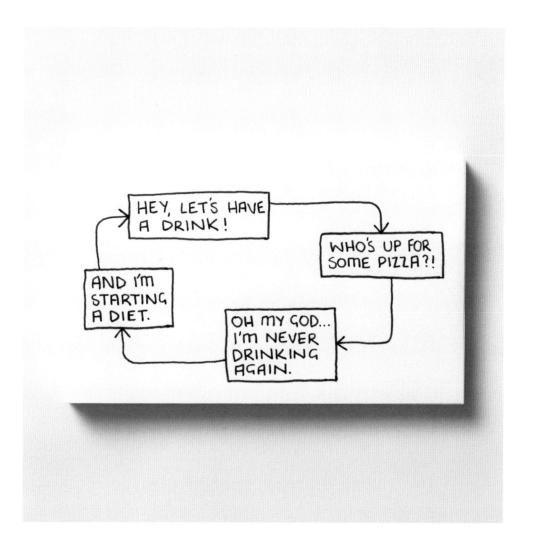

'After last weekend, I'm deciding to take it easy this weekend, but I guess coming out for one wouldn't hurt, right?'

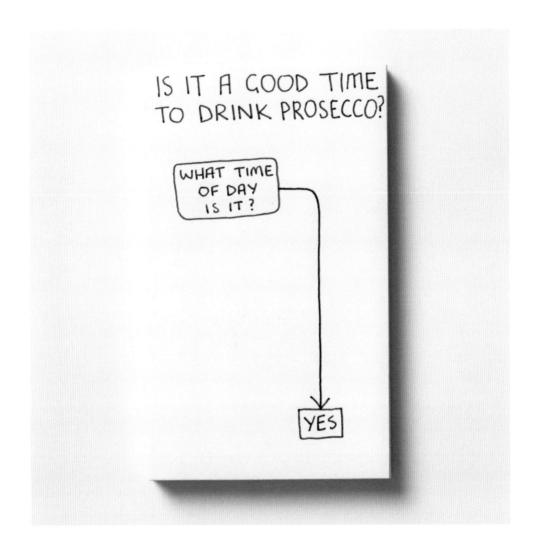

I'd love to sound like a wine expert and tell you all the reasons why Prosecco is far superior to Champagne, but I'm not, so the only reasons I honestly have are that it's half the price and the bottles look a bit cooler.

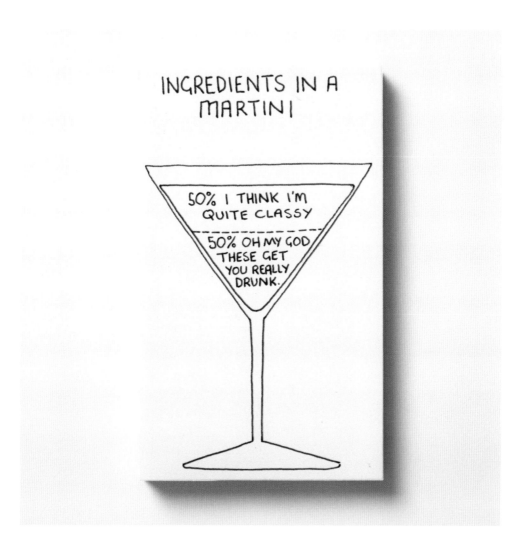

Ironically, while a Martini makes you look quite classy, they also cause you to eventually look very, very not classy.

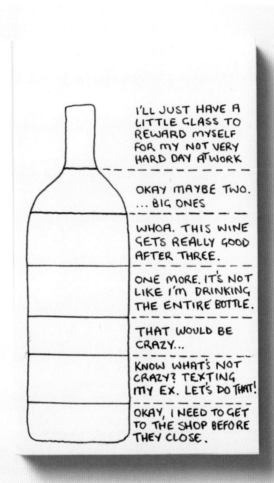

There's a few moments you encounter as you move through your 20s where you have that 'Oooh, I think I might be becoming an adult' moment. For me, it was the moment I polished off a bottle of red on a completely nondescript week night while watching TV, because if getting sloshed on your lonesome in order to forget your stressful day and having nobody to answer to for that isn't the most adult thing there is, I don't know what is.

Actually, yes I do: calling in 'sick' the next day because you're not feeling too great.

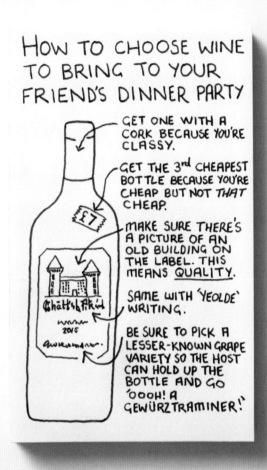

HOW TO CHOOSE WINE TO BRING TO YOUR FRIEND'S DINNER PARTY

GET ONE WITH A CORK BECAUSE YOU'RE CLASSY.

GET THE 3rd CHEAPEST BOTTLE BECAUSE YOU'RE CHEAP BUT NOT *THAT* CHEAP.

MAKE SURE THERE'S A PICTURE OF AN OLD BUILDING ON THE LABEL. THIS MEANS <u>QUALITY</u>.

SAME WITH 'YE OLDE' WRITING.

BE SURE TO PICK A LESSER-KNOWN GRAPE VARIETY SO THE HOST CAN HOLD UP THE BOTTLE AND GO 'OOOH! A GEWÜRZTRAMINER!'

... And obviously you won't bother buying any until you get to your friend's house, which turns out to be in the middle of nowhere, and the solitary corner store only sells Sauvignon Blanc, which you just know the host will inform you is *so 10 years ago*, and you'll have to tell them that as well as forsaking good coffee and decent public transport connections when they moved into this neighbourhood that maybe it's time to give up being a snobby amateur sommelier as well, and as usual you've ruined the dinner party again.

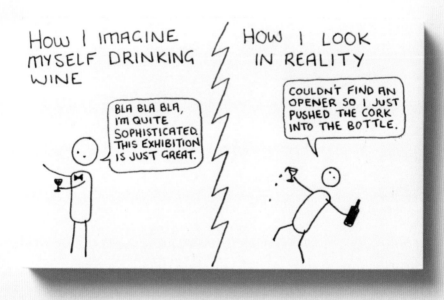

I like how wine is at both ends of a scale of sophistication. There's people quaffing glasses of red while they swan around exhibition openings, while the homeless dude in the gutter out the front is also drinking wine. The trick is to be perfectly situated halfway between the two.

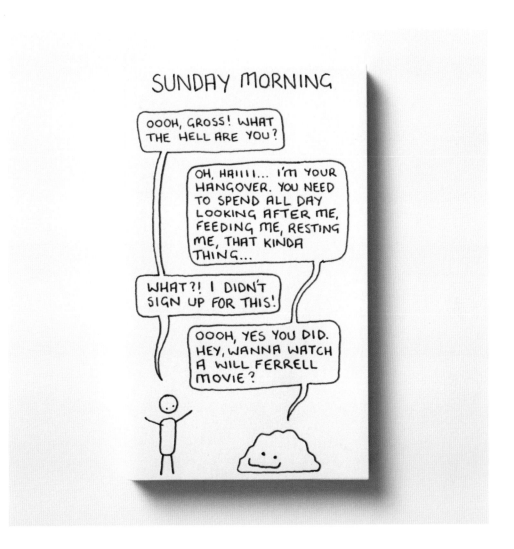

'... Oh, and also, I can't go outside all day, and if you could keep me away from bright lights, loud noises and regrettable memories of last night then that would also be ideal. Now, go cook me up some bacon, please.'

TECHNOLOGY

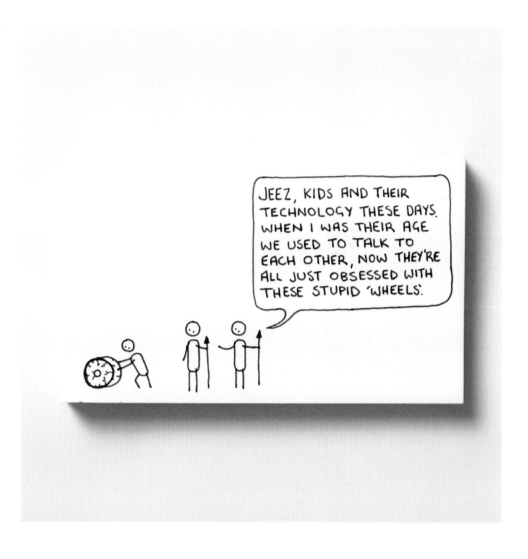

'Nobody appreciates a good hand tool these days. It's just sad, you know? I tell you, society is just going down the drain.'

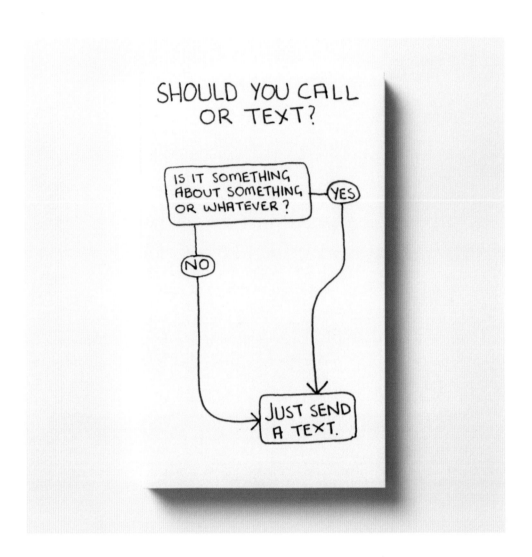

They say if you want to get something done, then pick up the phone. But that would mean you have to talk to someone, so the 'email them a few times' method is a much better option, which is also why I don't have a job any more. Still, I wrote some great emails.

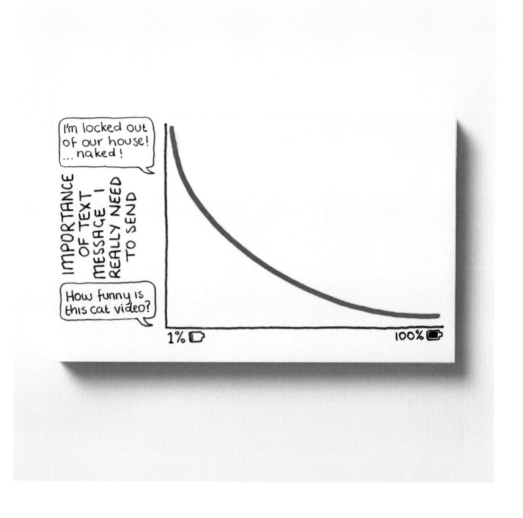

One per cent battery puts more fear into me than a lot of things that should really put fear into me. *Look, guys, I know we desperately need to seek higher ground in order to escape the inevitable tsunami that this impending asteroid is about to create, but do you think we could stop by a pub on the way so I can get some charge on this phone?*

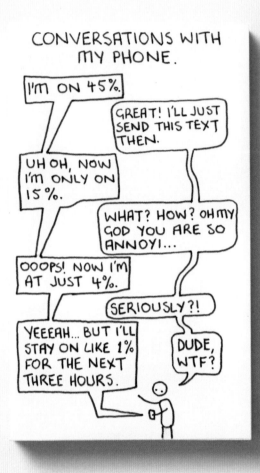

There's that point when your beloved phone finally does run out of battery, and you plug it back in and sit there waiting for it to restart, begging it to wake up as if you're at the hospital bedside of a loved one who's in a coma, and then you start telling it all the things you should have told it when it had battery and then you suddenly realise that maybe, just maybe, you're a little too attached to your phone.

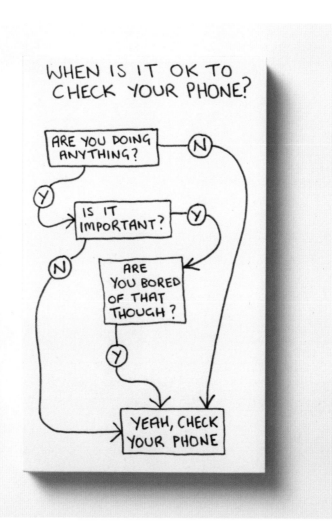

One day, the tide will turn. And all those people complaining that unnecessary phone use is rude will eventually die out and all that will be left is the notion that not using your phone and just staring into space actually makes you look a little bit creepy.

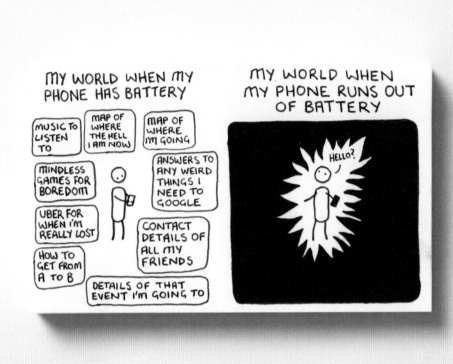

In 1914, Ernest Shackleton and a crew of 27 men set off to cross Antarctica. Their ship, *Endurance*, was eventually trapped in ice and (failing to live up to its name) finally sank, stranding the men with no chance of rescue. Months later, they boarded their life-boats as the ice melted, eventually reaching an uninhabited island. From there, Shackleton and four others made an 800-mile sea journey in a small open boat until they finally found help.

Thankfully, Shackleton would die long before he could discover how much worse it is when your phone runs out of battery on a Saturday night and you've got no way to find that house party.

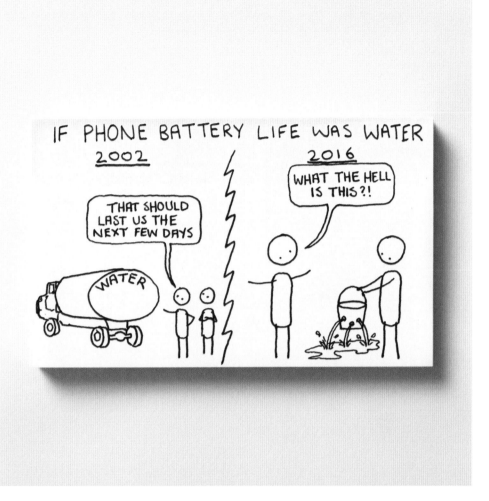

Nowadays I take a phone charger everywhere with me, which means I cart around a phone that I need to plug in to use, which someone could have done back in the 70s. Which means I'm wandering about with the same level of technology my parents had at the same age. How did this go so wrong?!

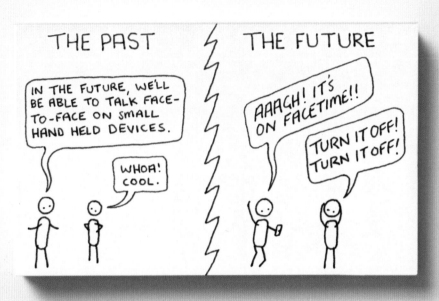

In Stanley Kubrick's 1968 film *2001: A Space Odyssey* the main protagonist makes a video call from an orbiting space station to his daughter on Earth. The scene is designed to show how technologically advanced the future will be, but if the film had been an accurate prediction his daughter would have screamed into the phone, 'I'VE TOLD YOU NOT TO VIDEO CALL ME, DAD!' This indicates that Kubrick completely misjudged technology's relationship with mankind, which is quite ironic.

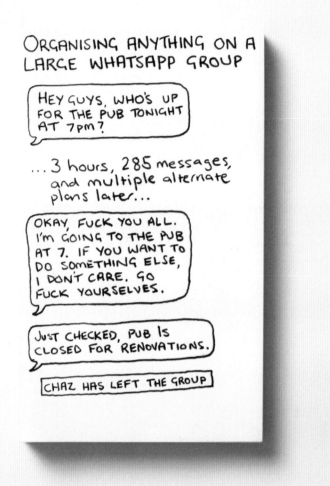

I used to spend a lot of time wondering how it was that the government never seemed to be able to get anything done, but I get it now.

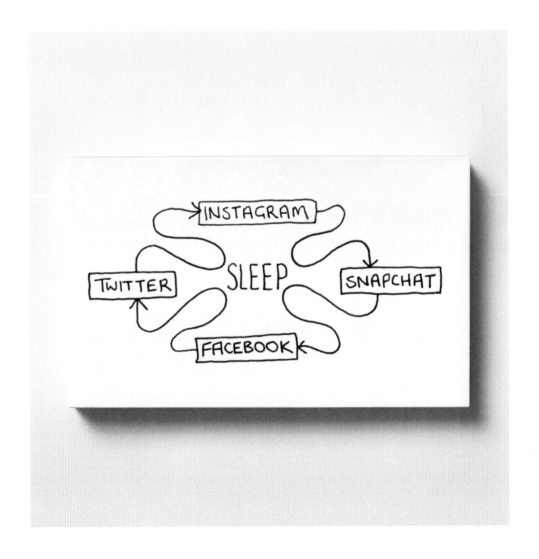

Eventually I'll complete a lap where I don't encounter any new notifications, and then, and *only then*, will I sleep.

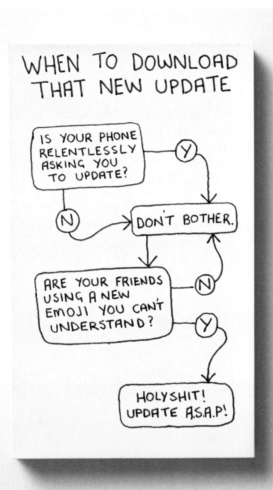

The terrifying reason I don't want to download the update is because I don't want to know what happens when your phone is out of action for 45 minutes and there's nothing to stop the existential dread slowly seeping in and washing over you, reminding you that you're ultimately alone and can't possibly cope within this cerebral vacuum.

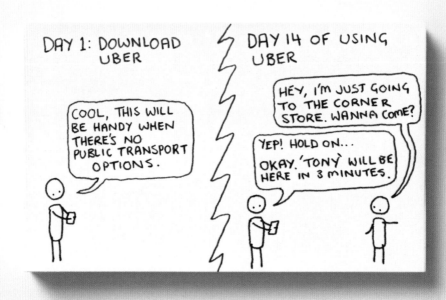

'Do you think we'll need drinks, or do you think Tony will have some?'

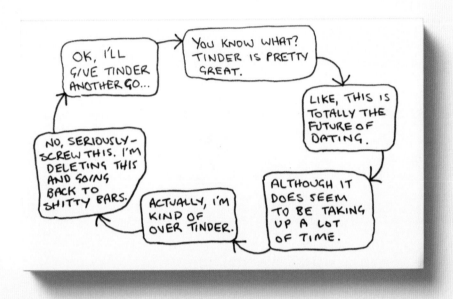

Online dating is basically the equivalent of walking into a room full of strangers, telling all the people you find unattractive to leave, at which point about a quarter of the people remaining in the room will ask how your Monday was and another quarter will say some weird, creepy stuff, so you tell those ones to leave as well. Then you talk to the remainder, who all turn out to be way too into martial arts or think Coldplay are the height of musical achievement, at which point you decide it's all too hard and so you leave the room and go read a book and think about how it's quite good having a cat and being alone forever.

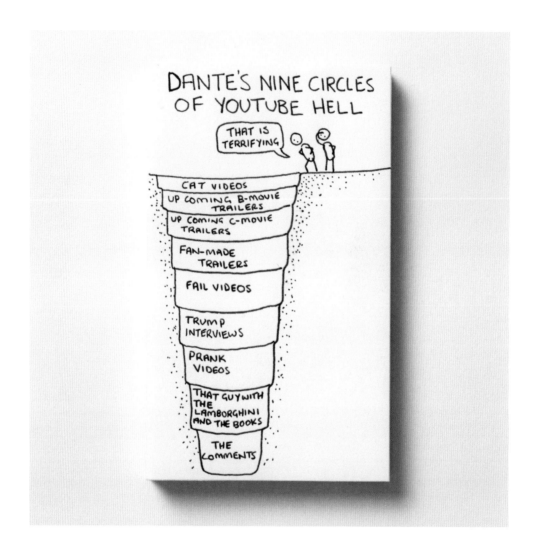

Dante would have loved YouTube. Granted, he would have spent a lot of time on it procrastinating and as a result would have failed to write *Inferno*, but he probably would have come up with some killer stuff in the comments.

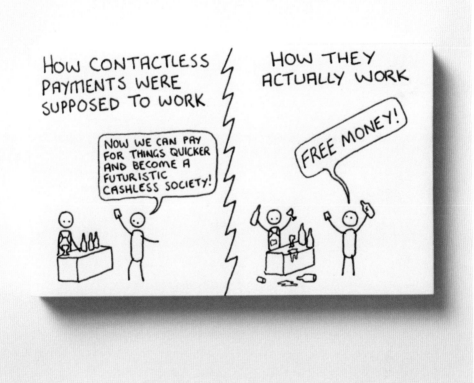

Before money existed, people used to just trade goods instead. Back then, you could walk into a pub, plonk a live chicken on the bar and receive two and a half pints in return. If anything, contactless payments just mean fewer live chickens in pubs, which is less fun for everyone involved.

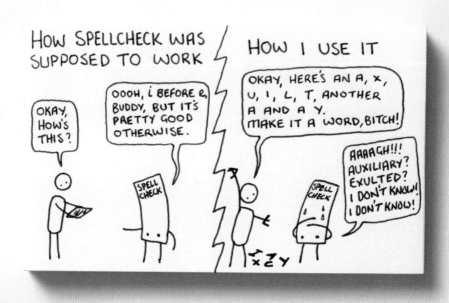

'Nope, not it. Have another guess with some extra letters. And don't make me have to go and google this, because you know Google will know it.'

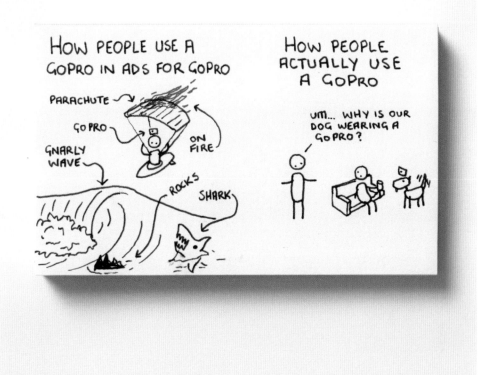

'Hey, we can do timelapse! What if we did a timelapse of something cool, like um ... like something cool that we do that would look really good sped up, like ... you know, any of the cool stuff that's around here ... Jeez, I don't know, there's just so many options ... one of which I'll think of eventually ...'

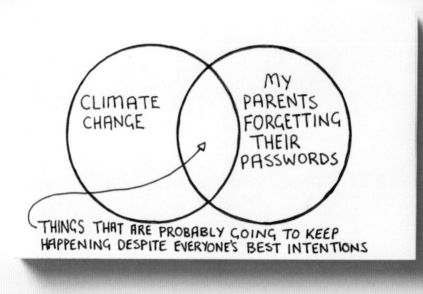

The other similarity these things share is that no matter how much you explain their importance, old people will invariably fail to understand or even bother listening in the first place.

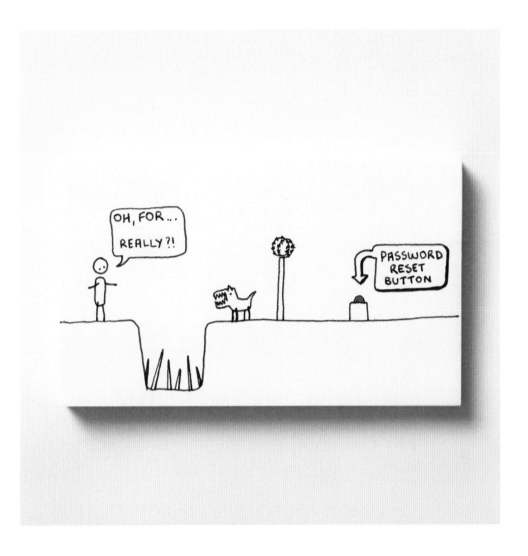

Some people wonder when the robots will take over, but I've got a sneaking suspicion it'll be when the last human finally locks themselves out of the internet.

ASSORTED NONSENSE

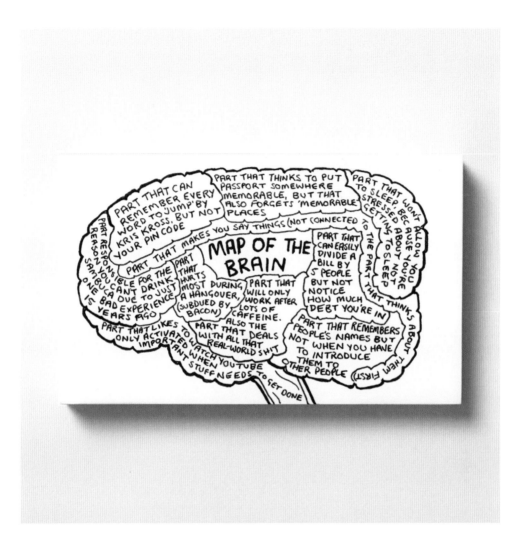

A neuroscientist told me that this map *looks about right*, which either means I've somehow just guessed what's going on in a brain, or neuroscientists have a worryingly broad definition of what counts as *about right*.

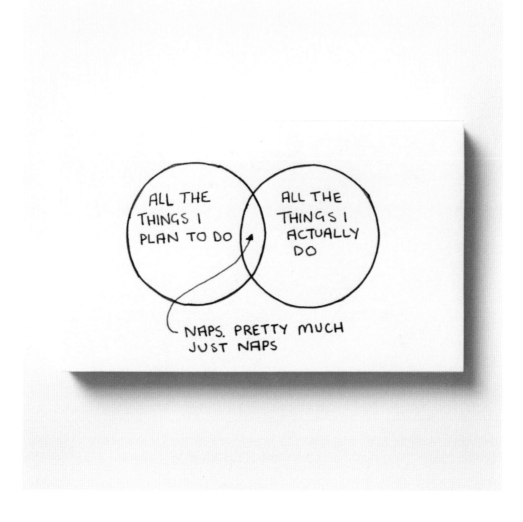

If I'm completely honest, 'naps' come under *Things I didn't plan to do* as well.

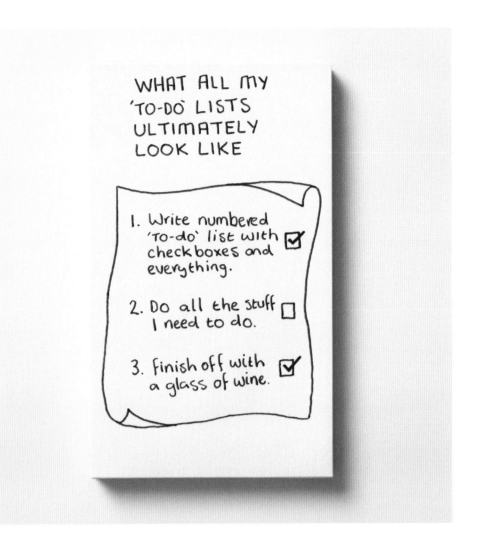

'We should probably list all the drinks individually so the list looks a bit more impressive, right? Also, let's put in 'Wake up' and 'Have a shower' at the top to pad it out a bit. Oh man, look at us now, we are getting so much stuff done!'

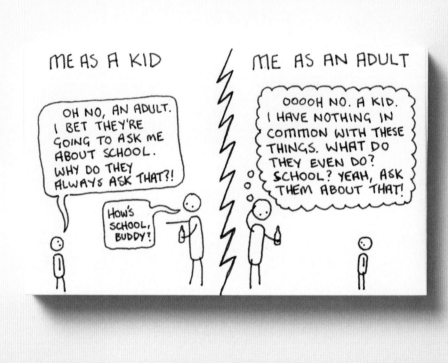

Lately I've been changing it up a bit and scaring the hell out of my friend's adolescent children – 'So, Johnny, what drugs are the kids doing at school these days?'

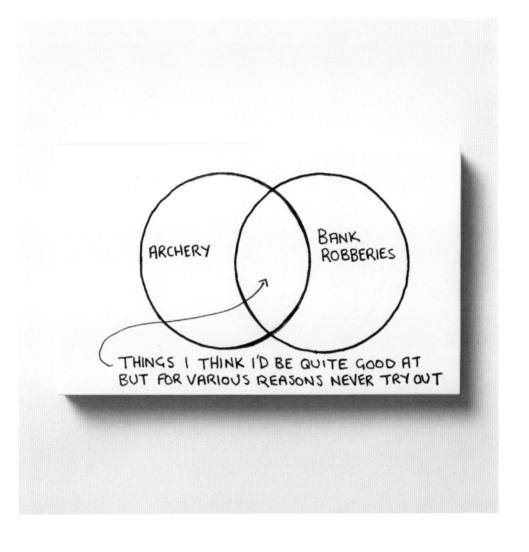

ARCHERY

BANK ROBBERIES

THINGS I THINK I'D BE QUITE GOOD AT BUT FOR VARIOUS REASONS NEVER TRY OUT

That said, I highly recommend trying out archery first, because discovering you can't hit a bullseye is probably a lot less worrying than realising you've accidentally mistaken the post office for a bank and now there are many armed police waiting for you to come out.

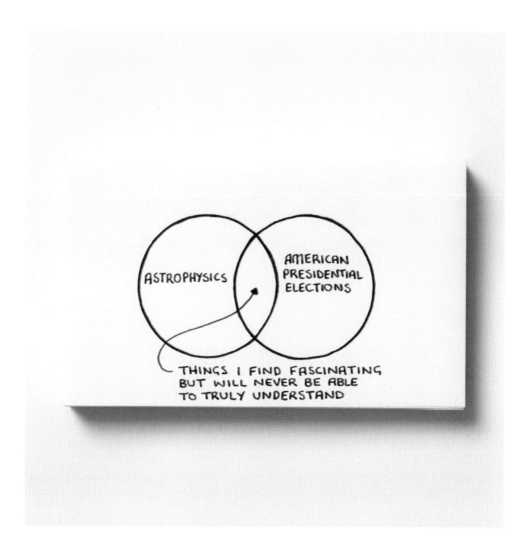

Sadly, only one of these fields requires you to be quite smart in order to succeed in it.

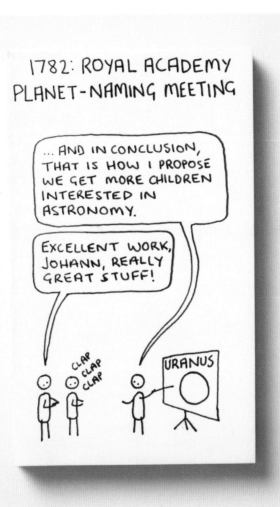

In 1917, Marcel Duchamp submitted an upturned porcelain urinal, signed 'R.Mutt' and titled *Fountain*, to the exhibition of the Society of Independent Artists, who deemed the sculpture to be unacceptable. This artwork has since become one of the most influential of the 20th century, as it called into question the very definition of art itself. However, I wonder if Johann Elert Bode beat Duchamp to the punch 135 years earlier when he named an entire planet with an arse pun, forever severing the traditional idea that science was supposed to be some pretty serious stuff.

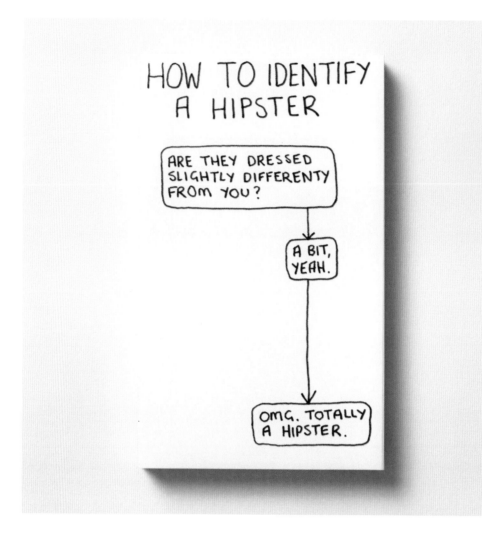

You might think someone's a hipster, but that person thinks someone else is a hipster, and someone, somewhere, thinks you're a hipster. Which means nobody is a hipster, and the entire thing is just a relative concept most often deployed in order to reconcile the fact that we're all a little bit different by administering preconceived clichés to the perceived rungs of an entirely imagined social structure. When, in fact, everyone is usually quite nice if you take the time to talk to them and compliment their ridiculous hat.

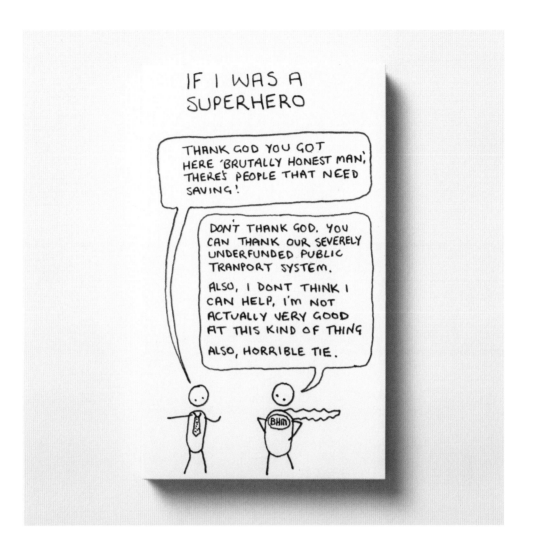

I'm pretty confident that after I give my supervillain nemesis a long and thorough PowerPoint presentation highlighting the economic infeasibility of their plan for world domination, they'll be willing to give up just to make me stop talking.

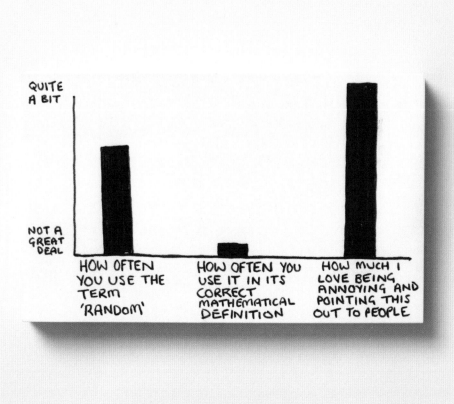

I don't know if I dislike people using the word 'random' because they're not using it by its exact mathematical definition or if I just don't like the kind of people who use it in the first place, and pedantically pointing out their misuse of the word is one way to really annoy them. Because if there's anything people like that hate, it's some random guy smugly pointing out how probability works.

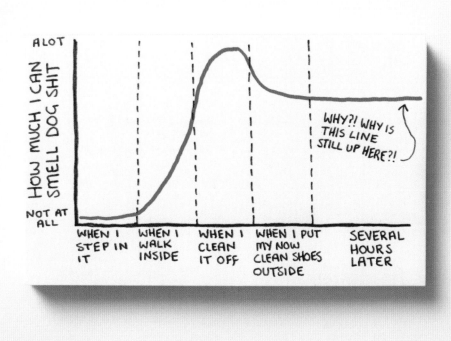

They say when you lose a limb you can still feel it, and in many ways I feel like dog shit is exactly the same. While you know you thoroughly washed it off hours ago, you can still somehow feel its presence and you're pretty sure other people can too, which has got to be why everyone is staring at you. Or maybe they're just looking in your general direction ... Either way you should get home at once and burn all your clothes just to make sure.

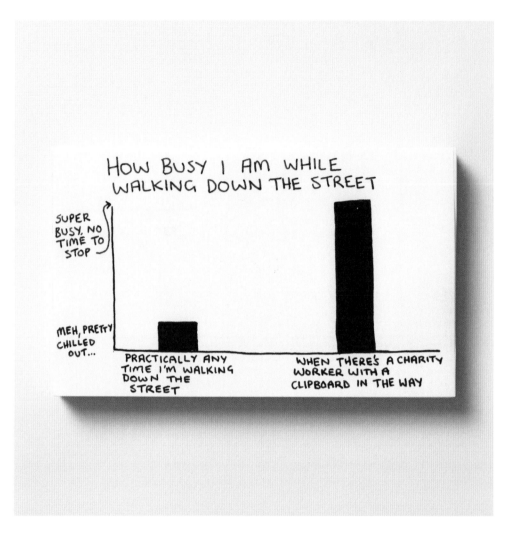

I have that face. Every time I walk past them they think, *Here comes a guy who won't mind giving up two minutes of his time to hear about the depleted numbers of obscure tree frogs in a particularly remote part of somewhere or other.* So I then do everything I can to make it look like I'm a busy, angry, slightly unhinged member of society who should not, under any circumstances, be stopped in the street to discuss a frog.

And yet, they do.

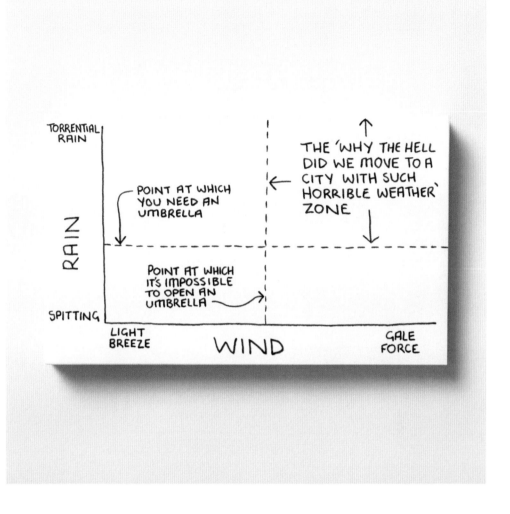

I love how the two things that are key to life on Earth are air and water, yet when it comes to living on Earth, these are the two things we generally complain about the most.

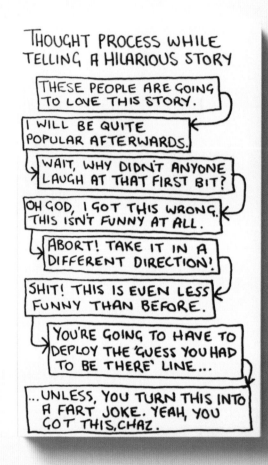

There's nothing quite like being in command of a story that is headed at top speed into a conversational car wreck when you realise the brakes don't work.

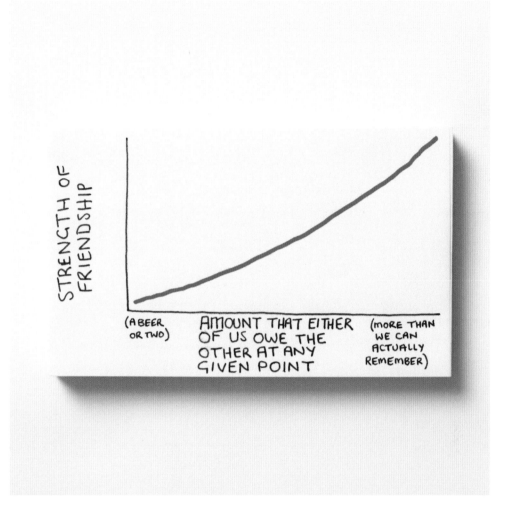

STRENGTH OF FRIENDSHIP

(A BEER OR TWO) AMOUNT THAT EITHER OF US OWE THE OTHER AT ANY GIVEN POINT (MORE THAN WE CAN ACTUALLY REMEMBER)

'Right, I'll buy this round because I owe you a round from last week. Of course, you still owe me dinner from the week before that, but then again you paid for accommodation during that wedding last month, so ... screw it, who cares?'

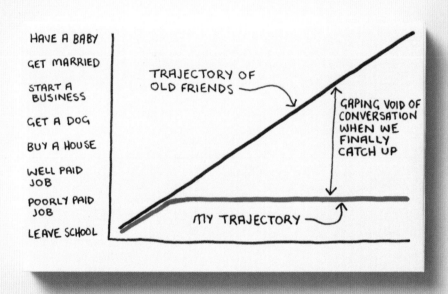

'So anyway, Linda and I are thinking of buying a second house in the country-side; it's mainly an investment property but would be a good weekender and a nice place for the dogs to run around, not to mention the kids! Have you made any investments lately?'

'Yeah, I bought an avocado three days ago that should be about to deliver big time.'

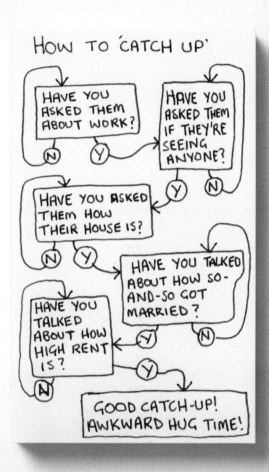

'Oh my God, I saw Sarah the other day and she mentioned she saw Steve. Can you believe that? It's, like, just so predictable these days, like I don't even know any more. Hey, are we getting the calamari? Speaking of which, how's your work going?'

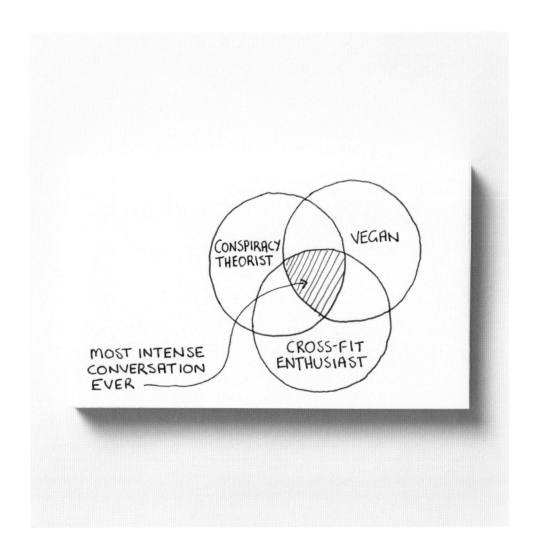

Somewhere out there is a guy who does cross-fit, is also vegan and also has some interesting things to say about 9/11 and the Moon landings. That guy is the most interesting guy that guy knows.

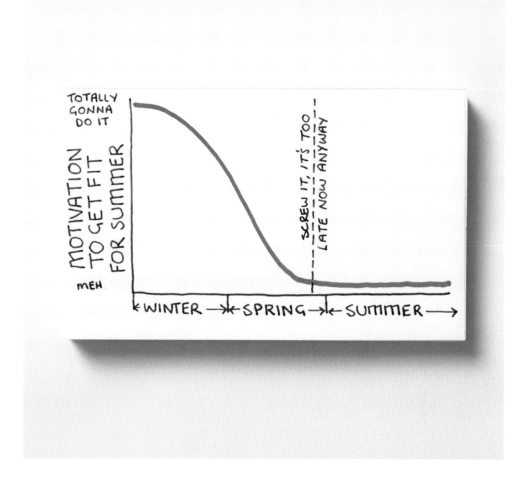

Plan B: Just buy a whole new wardrobe and instead of being fit, just concentrate on looking utterly fabulous.

GYM MOTIVATION VENN DIAGRAM

TIMES THAT
I AM MOTIVATED
TO GO TO
THE GYM

TIMES THAT
I AM ABLE
TO GO TO
THE GYM

5pm: 'It's really important that I get up at 5am and go to the gym tomorrow morning.'

5am: 'Okay, while the gym is still important, I feel like getting a proper night's sleep is far more important right at this moment and so getting up would be like ... actually dangerous for my health.'

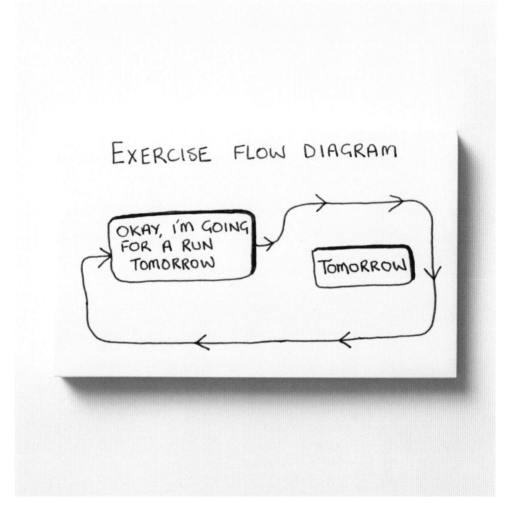

'Yes, I know I always say tomorrow but ... tomorrow.'

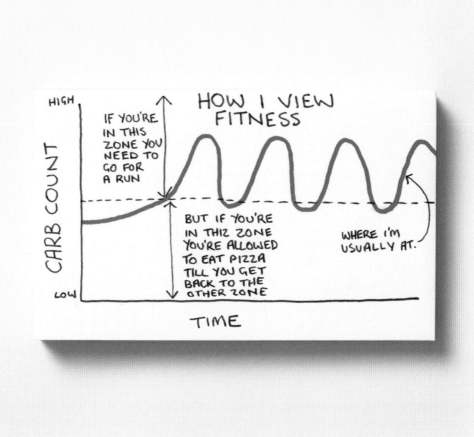

The number of calories you burn walking to the fridge totally justifies all the bacon you take out of it. At least, that's what helps me sleep.

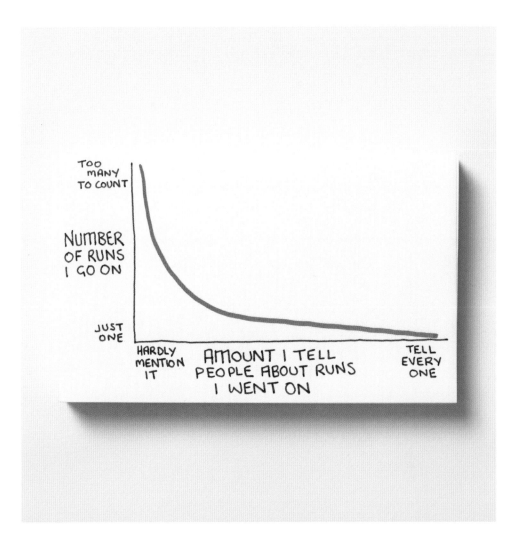

This completely flips if you've just run a marathon, in which case you'll no doubt be talking about that a lot.

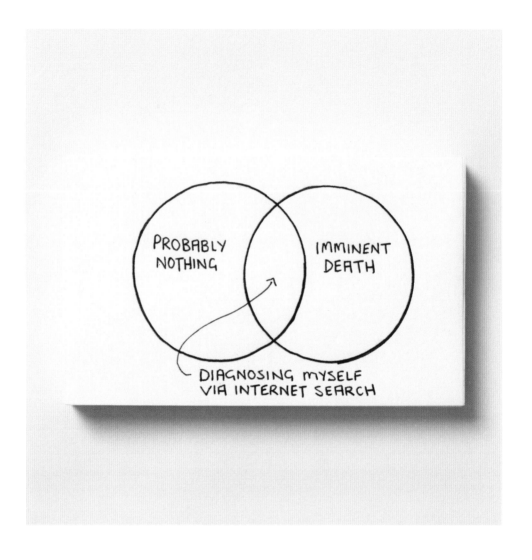

Admit it, you've probably got Ebola, Zika, legionnaires' disease or some obscure tropical disease that makes your arms fall off, and it's only a matter of hours until you start projectile bleeding out of your eyes.

Or it could be the flu.

But probably not. Time to freak out.

There's a good chance Rapunzel quite liked living with her folks, and just made up the 'being trapped in a tower' thing as a good excuse for why she hadn't bothered moving out into a dodgy flatshare. I don't blame her either – it's tough for Gen Y to support themselves – so if you can cook up an elaborate story that saves on rent and bags you a prince in the process, then all credit to you.

SCHRÖDINGER'S CAVITY

IT *COULD* BE A CAVITY, BUT UNTIL YOU SEE A DENTIST, IT COULD ALSO *NOT* BE A CAVITY.

THEREFORE, NOT SEEING A DENTIST GIVES IT THE GREATEST CHANCE OF IT NOT BEING A CAVITY.

If you can use quantum superposition and an ambiguously vital cat to explain to your parents why you still haven't been to the dentist it sounds very impressive, and they'll begin to harbour fantasies that you're going to eventually become a world-renowned physicist, albeit potentially one with no teeth.

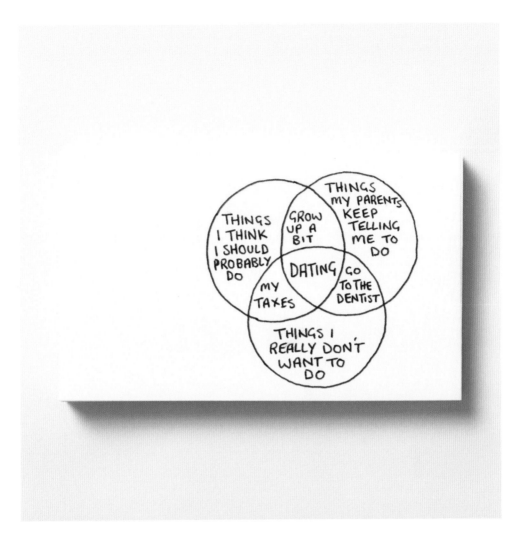

'... No, Mum, I haven't tried dating a dentist yet ... Yes, I agree it's a clever idea ... You what? ... Wait, didn't I explain your Apple password to you last time? ... Okay, yes I can come over and fix that for you ... Okay ... Love you too, bye Mum.'

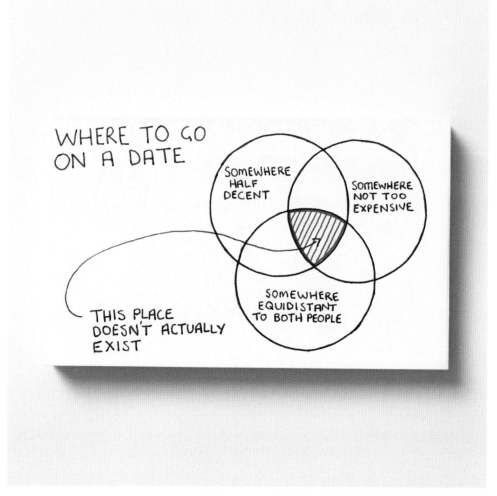

Say what you will about arranged marriages, but at least they don't have to pick date venues.

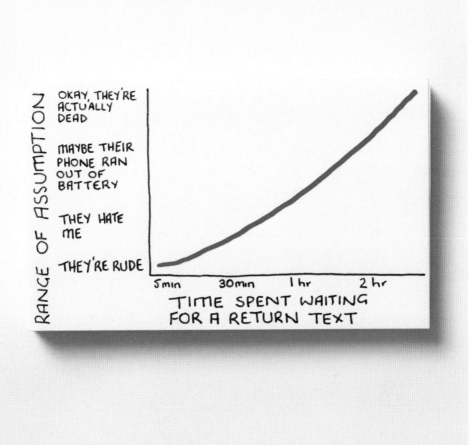

'Maybe they're watching a movie ... like a really long movie ... on repeat.'

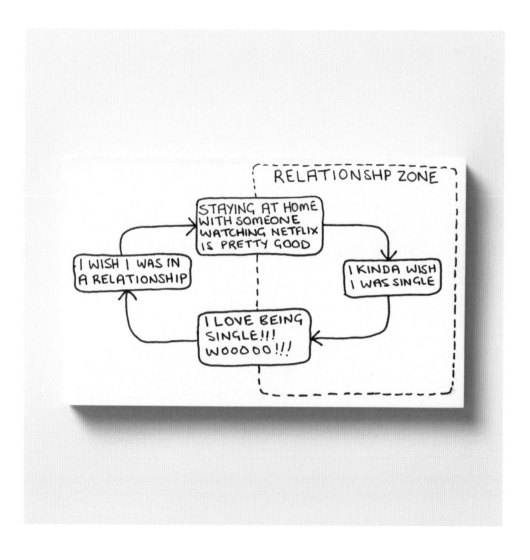

My father always told me that *the grass is always greener on the other side of the fence*, but then again he's a farmer, so it was always hard to tell if he was offering up some poignant advice, or literally talking about grass and fences.

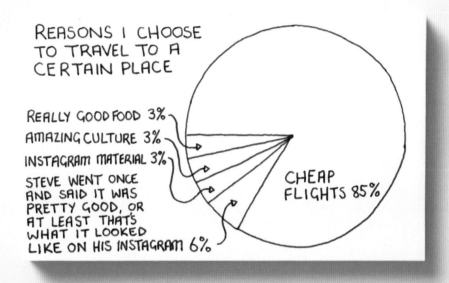

REASONS I CHOOSE TO TRAVEL TO A CERTAIN PLACE

REALLY GOOD FOOD 3%
AMAZING CULTURE 3%
INSTAGRAM MATERIAL 3%
STEVE WENT ONCE AND SAID IT WAS PRETTY GOOD, OR AT LEAST THAT'S WHAT IT LOOKED LIKE ON HIS INSTAGRAM 6%
CHEAP FLIGHTS 85%

It's actually cheaper for me to fly from London to a small European capital than it is for me to catch the Tube into Central London. Which is a relief, because I was sick of holidaying in Central London.

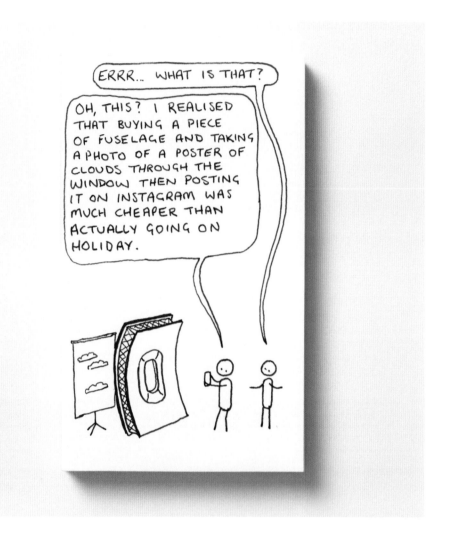

'Anyway, I told everyone I'm flying to Shanghai so I've got to head down to my local Chinese supermarket to get a few snaps there, if you want to come.'

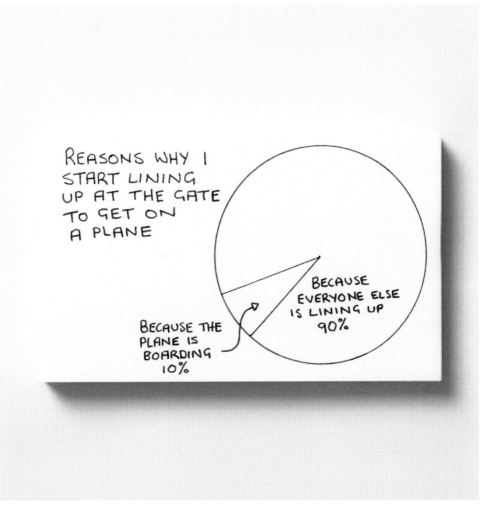

REASONS WHY I
START LINING
UP AT THE GATE
TO GET ON
A PLANE

BECAUSE
EVERYONE ELSE
IS LINING UP
90%

BECAUSE THE
PLANE IS
BOARDING
10%

I'll know I've made it in life if I ever become that effortlessly relaxed individual who casually gets up and swaggers over to the gate as the very last person to board. I mean, I assume that person exists, but I wouldn't know because I'm too busy fighting surprisingly strong Italian grandmothers for space in the overhead lockers. *Seriously, lady, are you even allowed to take that many tomatoes on a plane?*

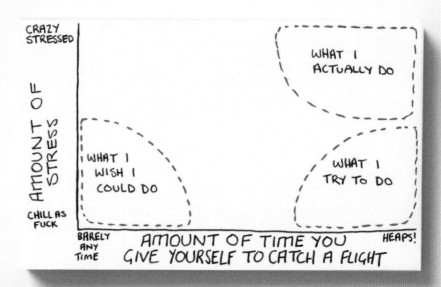

Wake up on time. Realise that might not have been early enough. Get train to airport. Train on time, but suspect it's going slower than usual. Begin to panic. Arrive at airport, discover long snaking queue moving slowly through security. Really panicking now. Formulate ways to jump the queue without looking like someone who shouldn't be let on a flight. Begin sweating in panic, customs officials now giving me that look they reserve for obvious drug traffickers. Finally clear customs, running to gate, freaking out. I'm going to miss this flight, how did I get this so wrong?!

Finally arrive at gate ... with two hours to spare.

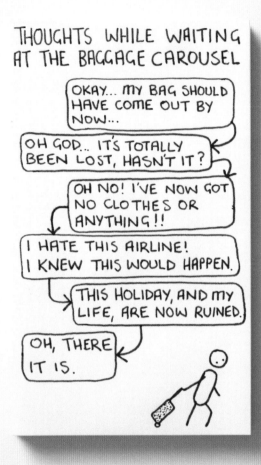

You can discover life writ large at the baggage carousel – everyone waiting around for their chance, jostling for position, tired, frustrated at those who've succeeded, surviving off hope as they stare down the line waiting for their bag to arrive, wondering if there's more to all of this mundanity, or if just waiting for your bag is all there really is.

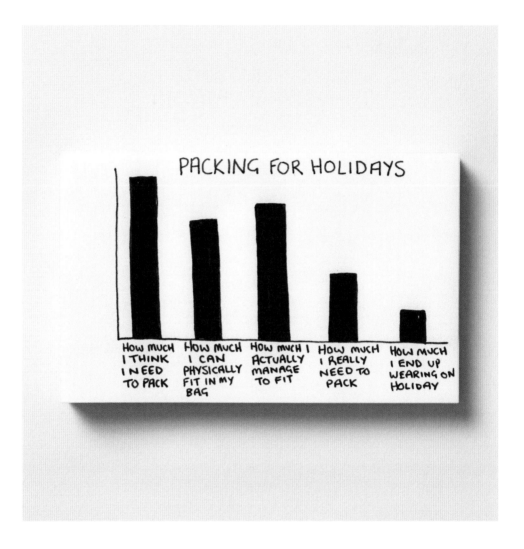

Who invented holidays? At some point someone was working away, probably seven days a week toiling in a field (or whatever it was people did before the internet), and they would have stood up, dropped their shovel, stared into the distance and said, *Screw this, I'm going to just go somewhere else for a bit and do nothing*. The rest of the workers would have stared at him in disbelief. *But, Steve, you can't just leave field-toiling and go somewhere else for a bit. Nobody's ever done that*, but Steve wouldn't have listened because he was a holiday visionary and then he would have walked off, gone home, packed way too many clothes and headed to the airport way too early.

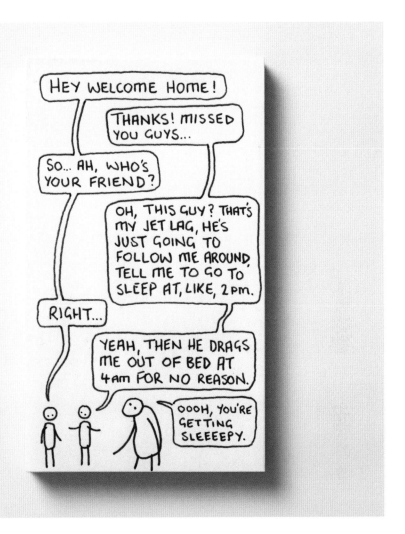

Like with poaching eggs or methods to stop hiccoughing, everyone has a remedy for jet lag, and every time it's something completely insane that the person spouting it has complete faith in – *Eat four oranges, take a sleeping pill, then go to the gym and smoke 16 cigarettes while walking backwards on the treadmill and that should cure it!*

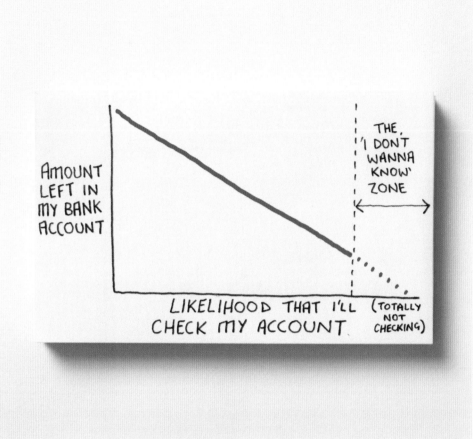

Would you like to withdraw cash? – YES

Would you like to check your balance? – NO

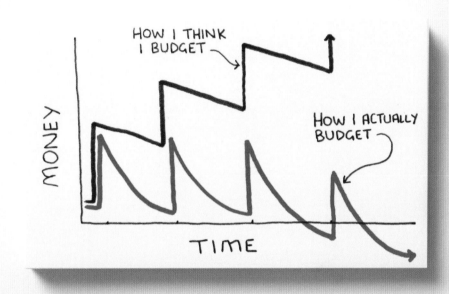

'How hard is it to sell your own kidneys?'

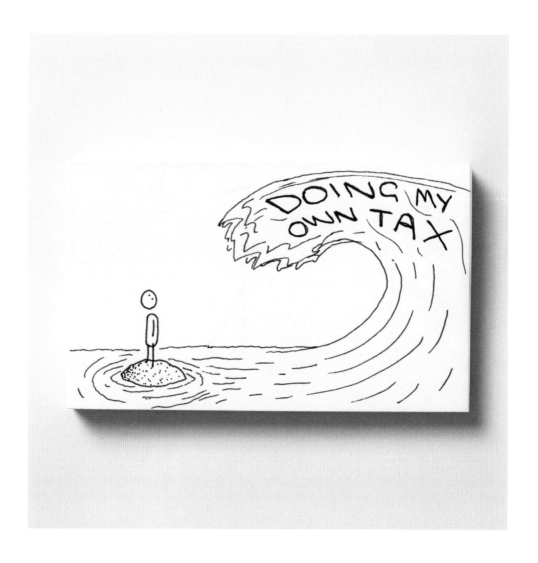

There's a moment between when you're earning enough money for this to be an issue but not enough money to pay someone else to deal with it for you. At which point, the obvious and smart answer is to treat it like that lingering cough you've been ignoring, which is to refuse to believe it's anything serious until your housemate is forced to cart your half-conscious body to the nearest doctor.

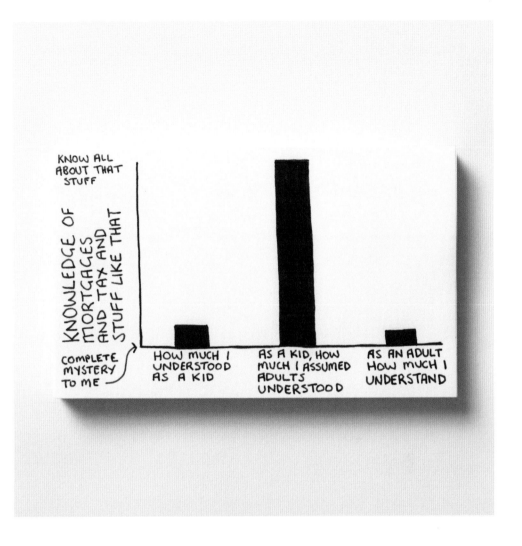

I always assumed a good understanding of this kind of thing occurred the same way grey or receding hair did – generally against your will and just in time to be taken seriously as an adult.

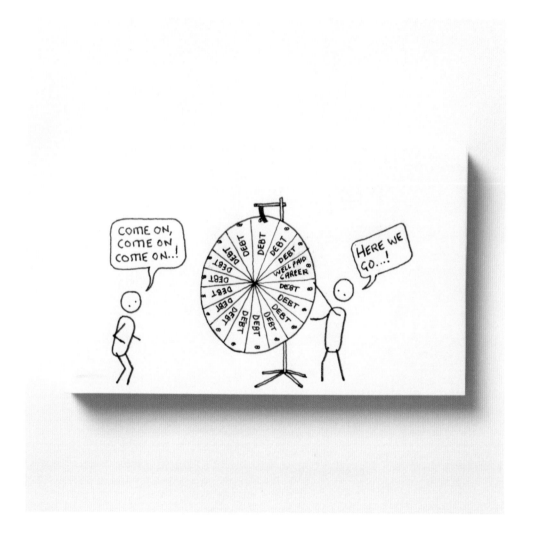

'We used to have a better wheel, but a bunch of old people wrecked it and now it no longer works for the rest of us.'

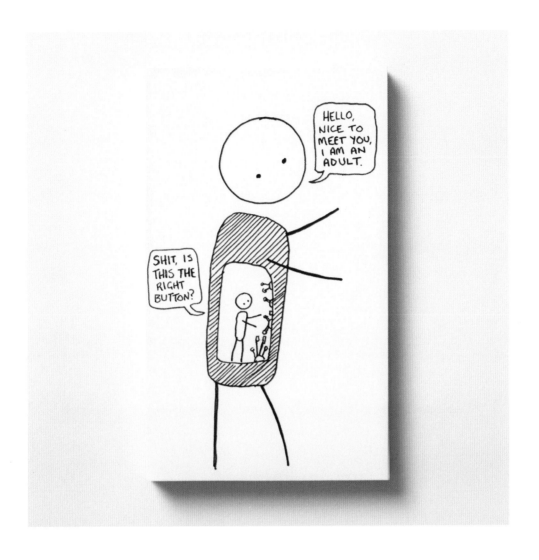

Pretty sure I'll be on my deathbed wondering when exactly it is that I'll start feeling like an adult.

Instalkerphobia

noun.

1. THE INTENSE FEAR THAT YOUR FRIEND WILL ACCIDENTALLY DOUBLE TAP WHILE THEY'RE USING YOUR PHONE TO LOOK AT THE PERSON YOU'VE GOT A CRUSH ON.

Friend: 'Oooh, what? You can't zoom? Oh, sorry, I think I liked a photo from two years ago.'

Me: (walks into ocean).

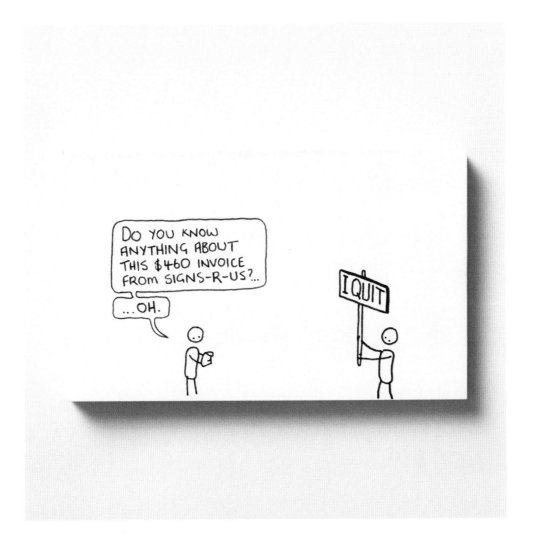

This has been a (mostly) true story.

ACKNOWLEDGEMENTS

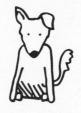

There are quite a few people without whom none of this would have happened.

I should probably thank Spencer Silver and Arthur Fry, co-creators of the sticky note, not to mention Ryosuke Namiki and Masao Wada, co-founders of the Pilot Pen Company, producers of the Pilot Fineliner, the most hardworking pen in my arsenal and my comedic weapon of choice. Also, Tim Berners-Lee and whoever invented Instagram, I guess.

However, the biggest thanks need to go to the members of a group message thread where I first began to post these drawings, who over several months convinced me to put them onto the internet. I repeatedly told them it was a terrible idea and nothing would come of it, and I've never been happier to be proven wrong. Gal, Pav, Fi, Rin – thank you a million times over.

Thank you to my amazing parents who dealt with the fact that their son was throwing away a career in architecture to draw idiotic things on sticky notes, not just well, but were also exceedingly supportive of the idea. To Sis and Lib, thank you for all your drawing ideas and for generally being the best sisters ever. Also, to my incredible Grandfather Paps, the countless lunches with whom would constitute a true Guide to Life book.

Thanks to my agents, Christopher and Nicola, without whom I'd have no idea what I was doing. Thanks to Jack, Emily and the lovely folks at HarperCollins, for guiding me through the world of publishing and pointing out that I actually use the word 'actually' way too much ...

To everyone in 'The Eurovision Warehouse' that's been my home and studio for the last year: Huw, Bremond, Josie, Anna, Marjut, Lior and Talia, thank you for respectively giving your English, French, German, Polish, Finnish and Israeli perspectives on all my jokes, as well as countless meals, drinks and general fun times (special extra thanks to Anna for her photography skills).

Thanks to everyone I used to work with in architecture who didn't seem to mind that I spent most of the time drawing comics and wasting time on the internet rather than drawing buildings. You know who you are.

London friends and lovers: Sophie Caroline Jepson for your incredible word generation skills, Lee-wah, Katie, JC, Scotty, Wakes, Pip and the rest of the Aussie contingent, the entire Russell family for being my away-from-home pseudo-family and of course Mr Hope, both friend and begrudging patron, thank you.

To Stoke Newington's finest: the guy who runs my local corner store for keeping up the avocado supply, The Good Egg for making the best breakfast and coffee in London, Original Sin for supplying all the pool and drinks a man could ever want – thank you.

Australian friends from home whose friendships have provided a lot of the material in this book: Trigger and Alice, Glenn, Mr Dan Salmon (and your excellent comedic brain), Georgia, Hugh and Tanja, Ange, and of course the best dog in the world, #BarryWiegard.

And, obviously, thank you to (at last count) the 130,000 people following the @Instachaaz Instagram. Without all those follows and comments and likes, this entire thing would still be a little-known procrastination tool that I would have lost interest in by now. The collective weight of this following served as proof that the Instagram might survive as a book, so without you all nobody would have discovered it, especially the kind of people who turn these things into books.

Thank you, thank you, thank you.